U0004990

Come in
and
see the cats!

── 這裡有 **貓**，歡迎光臨 ──

老外帶路，探訪62間貓店長私藏地圖！
Take a tour of 62 cat cafes and shops!

Susan 著

晨星出版

目 次

📍 Chapter 1. 有貓的咖啡館 Cafés with cats

📍 Chapter 2. 貓主題咖啡館 Cat-themed cafés

📍 Chapter 3. 貓超多的咖啡館 Cat cafés with lots of cats

📍 Chapter 4. 更多有貓的好地方 Other places with cats

📍 Chapter 5. 不只有貓的寵物咖啡館 Pet cafés

Preface 序言

The purpose of this book is to be a complete guide to cat cafes in Taiwan. I've tried to include all the cafes currently in business, though I may have missed a few. The ones that I've written more extensively about and included introductions to the cats for are the ones I consider my favorites. I've given my personal impression of all the cafes based on my experience.

There is such a wide variety of cat cafes in Taiwan, something to appeal to any cat lover. In my opinion, the best cat cafes have happy, healthy cats (whether it's one cat or ten), are clean, have a good atmosphere, creative design and reasonably good drinks and food. Some people might just want to see lots of cats and not care about other factors. Others might be looking for a quieter place or just any place in their vicinity that has cats. I hope that this guide helps everyone—Taiwanese, expats, tourists—find their favorite kind of cat café.

編寫這本書的初衷,是為了能介紹所有臺灣的貓咖啡。我儘量將臺灣所有我知道,還在營業的貓店家介紹給大家,但是可能有一些我不知道而被遺漏掉。我也盡我所能地介紹我所知道的貓店長,以及我特別推薦的店家。書中提供的個人感想,也都是來自於我自己的親身經驗。

臺灣有這麼多種不同類型的貓咖啡店存在,每一位喜歡貓的人一定都可以找到最喜歡的。我想最棒的貓咖啡店,必須有開心健康的貓(不管有幾隻)、店內環境乾淨、有好的氣氛、具有創意的設計特色,還有好吃好喝的東西。當然,有很多人可能只想跟很多貓咪們玩,而不在乎其他因素。如果你比較喜歡安靜的地方,也或許只想找附近最近的貓咖啡,我希望這本書能幫到所有的人,找到屬於自己的貓咖啡店。

Susan M. Swier

Chapter 1
有貓的咖啡館
Cafés with cats

地　　址：臺北市大安區雲和街 48-1 號
Address： No. 48-1, Yunhe St., Da'an Dist., Taipei City
營業時間 Hours：週二一週五 Tuesday-Friday 17:00-24:00
　　　　　　　　週六一週日 Saturday-Sunday 12:00-24:00
最低消費 Minimum cost per person： NT$100
電　　話 Phone： 02-2369-1264

1 品客經典咖啡
Classic ★★★★★

This Shida café is down a small street near the former night market area and all the clothing shops. It has a quiet atmosphere with soft background music playing, and the staff are friendly and efficient.

The cats are also very friendly, and if you're lucky, they'll sit at your table. There are three cats in all, and while the café isn't exactly cat-themed, there are also some portraits of former café cats on the walls.

這間是隱藏在小路裡的咖啡館，在以前的夜市附近，附近有很多賣衣服的店。我很喜歡這間店的環境，有好聽的音樂和優質的服務。

這裡的貓都很可愛漂亮，很喜歡被摸。有一隻還跑來坐在我的桌子上，我超開心

的。他們有三隻貓，但是除了牆上有以前的貓咪的照片，沒有過多關於貓的裝潢。

They offer a full dinner menu, and it tends to get more crowded around dinner time. Dinner options include various pasta meals and specialties of the day. For coffee, there's a variety of gourmet blends, including some

from Kenya and Brazil. The cheapest menu item is an espresso for NT$90. The first time I went, I had a café mocha with banana flavoring for NT$120, which was quite good. I've also had a hot coffee with Kahlua （NT$180）, and that was also delicious.

　　菜單提供很多種套餐，所以晚餐的時候人會比較多。可以選義大利麵或是當日特餐。咖啡有很多種，包含非洲、巴西等等不同風味。最低消費是黑咖啡（NT$90）。我第一次造訪的時候是喝香蕉摩卡（NT$120），我也喝過熱咖啡加卡魯哇 （NT$180）味道一樣很不錯。

貓店長的故事 Cat's story

The oldest cat in the café is KK, a beautiful 15 year old male Chinchilla cat. The owner has had him since he was 8 months old. KK was originally owned by a couple, but they broke up and left him to the boyfriend's parents. Unfortunately, this was during the SARS outbreak and the parents believed cats spread germs, so they didn't want KK anymore. KK has been happy in his home at the café. He had another cat friend, but this cat passed away ago, and KK showed real grief, not wanting to play or be with people for three months. He tolerates the other café cats but isn't very close to them. Now, he's mostly recovered his old spirits and will be happy to come to people's tables and even lick their hands.

這裡年資最高的貓是 KK，他是一隻很漂亮的十五歲公金吉拉。老闆在他八個月大的時候開始養他。他原本的主人是一對情侶，因為分手所以決定不養，男生的父母也反對養他，因為當時亞洲正在流行 SARS，他們怕 KK 會傳染疾病。KK 現在在咖啡館住得很開心。以前這裡也有一隻貓，KK 跟牠的感情很好，牠去世的時候 KK 憂鬱了好久，整整三個月都不願意跟任何人和貓互動。現在他終於走出了陰霾，也會主動來客人的桌子當招待，很愛舔客人的手。

The other cats are Hei Gugu, a sweet little marble tabby, and Xiao La Jiao（Pepper），so named for her feisty disposition when she first came to the café. She's a Persian who was kept in a cage in a pet store for years.

It took her a while to get used to people, but now she's happy to be petted and you can often see her on the counter watching the staff make coffee.

另外兩隻貓是黑咕咕，一隻可愛小灰白色貓。還有小辣椒，這個名字是因為她剛來的時候很兇，她是一隻波斯貓。住在一個寵物店的籠子裡整整四年，很可憐。

她剛到這裡的時候很怕人，但是現在已經很習慣了。她喜歡人摸她，也很喜歡看店員做咖啡。

 我的感想 My overall opinion

This is a café that I've brought friends to a few times. I know it's clean and has good coffee and nice cats, and it's not too overwhelming for someone who isn't as much of a cat person. It's a quiet place to read, and they have outlets for chargers and computers. The Wi-Fi is just for the area in general and not for the café itself, but it seems pretty reliable. I love the fluffy cats, and it seems like the staff really care about them.

　　這間店我來過好幾次，也會帶朋友來。因為我知道這裡很乾淨，有好咖啡和可愛的貓。即使是不太喜歡貓的人，在這裡也能悠然自得，是一個適合閱讀的好地點。 他們有很多插座可以提供電腦充電，雖然沒有提供 Wi-Fi，但是附近有共用的熱點，所以我覺得還好。我很喜歡這些漂亮的貓，看得出來店員都很關心牠們。

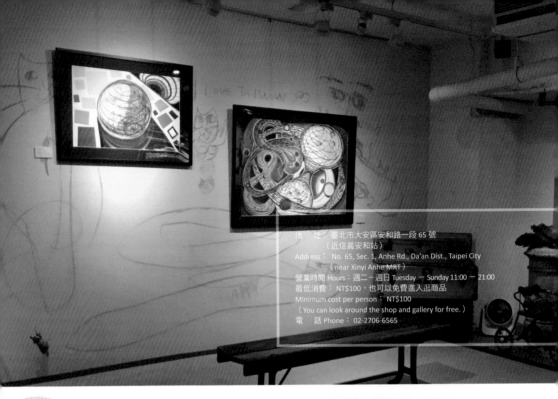

地　　址：臺北市大安區安和路一段 65 號
（近信義安和站）
Address： No. 65, Sec. 1, Anhe Rd., Da'an Dist., Taipei City
（near Xinyi Anhe MRT）
營業時間 Hours：週二－週日 Tuesday－Sunday 11:00－21:00
最低消費：NT$100，也可以免費進入逛商品
Minimum cost per person： NT$100
（You can look around the shop and gallery for free.）
電　話 Phone：02-2706-6565

2 安和 65
Anhe 65

★★★★★

This is a cat-themed shop, gallery and café that has three cats. It has adorable cat paintings and decorations all around.

這是一個複合型的貓主題商店，有畫廊和咖啡館。這裡有三隻貓，店裡也有很多可愛的裝飾。

And it's not just a café; they also sell cat-themed beer and wine, to drink there or in gift sets. The labels on the bottles are the artwork of Pepe Shimada and they also have paintings, posters and other items featuring his work. He has his own gallery in Houtong Cat Village.

There are sometimes events at the café featuring artists or musicians. Some of these are open to the public, and information can be found on their Facebook page. They also sometimes host private events at times when they would otherwise be open, so it's a good idea to call or check their calendar on Facebook when planning a visit.

這裡不只有咖啡，還有貓咪主題的啤酒和其他酒精飲料，可以自己喝或買來當禮物送人。每一瓶的標籤都是藝術家 Pepe Shimada 的作品，他們還有海報與其他商品。Pepe Shimada 在猴硐貓村還有自己的畫廊。

這裡偶爾會有藝術與音樂展演活動，有些是私人的活動，也有公開表演。可以參考他們 Facebook 的行事曆，追蹤這裡什麼時候有活動，什麼時候被包場。

The first time I went, I ordered a Neko beer （NT$180） and a jalapeno, sausage and cheese panini （NT$260）. The beer is a wheat beer, brewed in Taiwan but much better than most Taiwan beers. Another time, I went for dinner and found that the paninis are only available before 5pm. After 5, they only serve main dinner courses, so I ordered a spicy pasta with pepperoni and anchovies. （NT$260）. It was pretty good, though I preferred the sandwich.

我第一次到訪時，點了一瓶「貓啤酒」（NT$180）搭配墨西哥辣椒、香腸與起司義大利三明治（NT$260）。我後來也有來這裡吃過晚餐，五點以後沒有供應義大利三明治，所以我點了辣香腸義大利麵（NT$260）。不過我還是比較喜歡義大利三明治。

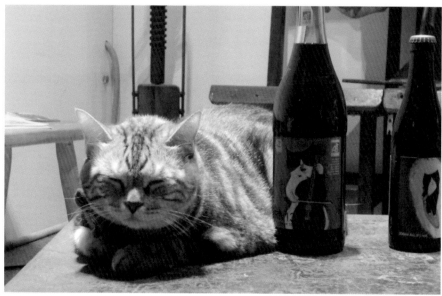

Two marble grey tabbies were adopted from Houtong cat village. They like to hang out by the door at the top of the stairs. They're lazy cats but happy to be petted.

The third cat, and the only one that I met the first time I went, is Xiao Yue, an easygoing black and white cat. She lets people pet her and if she likes you, she'll rub her head against you. She isn't from Houtong, but was found hit by a car in the area and was rescued.

現在他們有三隻貓,兩隻灰白貓是從猴硐貓村領養的,喜歡躺在門口的樓梯上。他們很愛睡覺,也喜歡被人摸。

第三隻貓是我第一次拜訪時認識的黑白貓,小月。很親人,如果她喜歡你,就會把頭靠在你身上磨蹭。她不是猴硐貓,是在店附近車禍受傷後被收養的。

 我的感想 My overall opinion

This café/restaurant/gallery has a sophisticated atmosphere, and is a good place to spend an evening even for someone who doesn't like cats. If it were open later, it would be a nice alternative to going to a bar. I've been there alone and with friends and had a good experience both times. If you want to pet cats, you can find them there, but people who aren't as comfortable around cats won't have to worry about the cats jumping on them or the tables.

這裡不論你是要當成咖啡店、餐廳或是藝廊都可以，環境非常雅緻。我想即使是不太喜歡貓的人也會喜歡這裡。如果來訪的時間比較晚，也可以當成一間小酒吧放鬆。我一個人到訪過，也有跟朋友一起來，感覺都很棒。如果想跟貓玩可以去找他們，如果有不喜歡貓的朋友，在這裡也不必擔心貓咪會跳到你身上或桌上來。

芭蕾咖啡館 café Ballet 的貓店長

3 特選 / 好茶好咖啡
Specialty coffees and teas

這些咖啡館都有特別、高級的咖啡或是茶葉，飲料就是他們的特色，而且至少有一隻貓店長在顧店。

All of the cafés in this section feature gourmet coffee or tea. They have at least one cat, but the main specialty is their drinks.

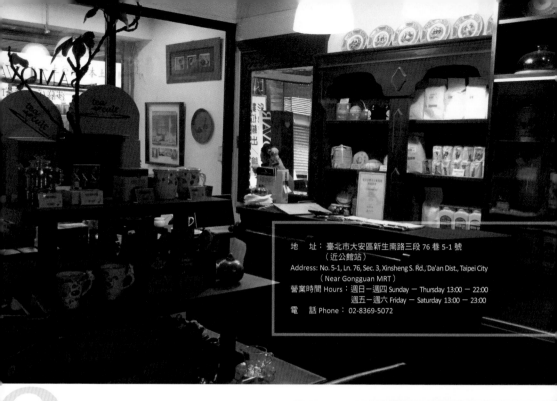

地　　址：臺北市大安區新生南路三段 76 巷 5-1 號
（近公館站）
Address: No. 5-1, Ln. 76, Sec. 3, Xinsheng S. Rd., Da'an Dist., Taipei City
（Near Gongguan MRT）
營業時間 Hours：週日－週四 Sunday － Thursday 13:00 － 22:00
週五－週六 Friday － Saturday 13:00 － 23:00
電　　話 Phone： 02-8369-5072

莎慕瓦典藏茶館
Samovar ★★★★★

Samovar, which has been near NTU for nearly 20 years, is less of a "cat café" than some of the others and more of a specialty tea room, with over 200 different kinds of tea. They have quite an extensive menu, but

the owner is quick to ask if there's any other flavor or type you want because there are many more not on the menu. When I've gone, I've gotten the afternoon tea set, for a choice of tea and a cake （NT$200）.

They have a beautiful, 17 year old long-haired grey cat. The place has a relaxing atmosphere, plenty of delicious teas to try and would also be a nice place to buy gifts as they also sell canisters of all the teas.

　　莎慕瓦典藏茶館在公館已經經營快二十年了，我覺得不算貓主題咖啡館，比較像特調茶館，他們有兩百多種茶葉與豐富的菜單。因為隱藏菜單很多，所以老闆都會特別問你想喝什麼樣的飲品。我都會點下午茶套餐（NT$200），有一壺茶和NT$60 以內的蛋糕。他們有一隻很漂亮的十七歲的灰色長毛貓。這裡的環境讓人放鬆，茶也都非常好喝，還可以買各式茶葉當禮物。

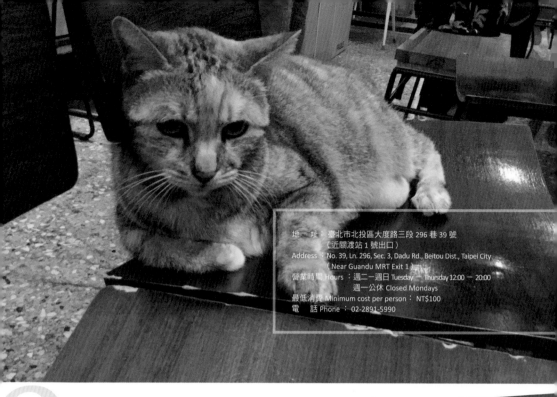

地　　址：臺北市北投區大度路三段 296 巷 39 號
　　　　　（近關渡站 1 號出口）
Address：No. 39, Ln. 296, Sec. 3, Dadu Rd., Beitou Dist., Taipei City
　　　　　（Near Guandu MRT Exit 1）
營業時間 Hours：週二ー週日 Tuesday ― Thursday 12:00 ― 20:00
　　　　　　　　週一公休 Closed Mondays
最低消費 Minimum cost per person：NT$100
電　　話 Phone：02-2891-5990

3
爐鍋咖啡
Luguo Café ★★★★☆

This café is not really cat-themed and it just has one cat, which only sometimes comes to the café with the owner. However, there are also a couple of friendly stray cats outside that the owner feeds.

雖然這裡不是貓咪主題咖啡，但是這裡有養一隻店貓。店貓來店的時間不固定，不過常常有兩隻貓咪老闆餵養的流浪貓會在店的外頭溜搭。

Even without cats, the café has a nice atmosphere and Wi-Fi. It also has a drum set and a piano.

除了貓咪以外，他們有好喝的咖啡。也有提供 Wi-Fi，還有一架鋼琴與鼓組。

They sell a variety of coffee beans from around the world, and grind them fresh. To go with the coffee, they have delicious cakes for NT$100 each. When the cat is there, it's friendly and will sit on people's laps or laptops. It's worth a visit, but don't count on seeing the cat.

這裡除了賣全世界的高級咖啡外，還有賣咖啡豆。這裡有很好吃的起司蛋糕與巧克力蛋糕，每片 NT$100。店貓有來上班時，會坐在人的身上還有電腦上，很值得一來，但是不一定會看到貓喔！

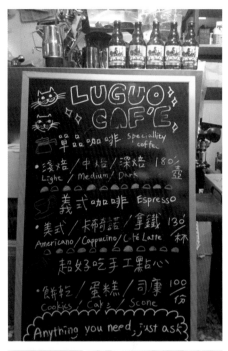

地　　址：臺北市大安區溫州街 74 巷號 5 弄 3 號
Address ：No. 3, Ln. 74, Wenzhou St., Da'an Dist., Taipei City
營業時間 Hours：週一 — 週五 Monday — Friday 12:00 — 22:00
　　　　　　　 週六 — 週日 Saturday — Sunday11:00 — 22:00
最低消費 Minimum cost per person：NT$120
電　　話 Phone：02-2369-0041

點亮咖啡
The Lightened ★★★★☆

I came across this place while wandering around the alleys near Gongguan.

I saw two cats outside and decided to go in. The cats are only outside though.

They do have lots of outdoor seating and since it was a nice day, I sat at a table with a cat.

這間店是我在公館四處逛逛時找到的。

當時我看到有兩隻貓咪待在外面，所以把我吸引進去。其實這裡是不能讓貓進去的。

外面有很多位置，所以我可以坐在外面的位置跟貓互動享受美好的一天。

The café's specialty is gourmet, 'direct trade' coffee. Inside the walls are decorated with pictures from the countries the coffee comes from.

這間店的特色是「Direct trade」，咖啡是從非洲來的，店裡面還有咖啡生產國家的照片。

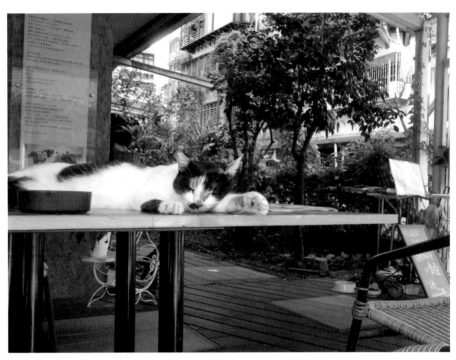

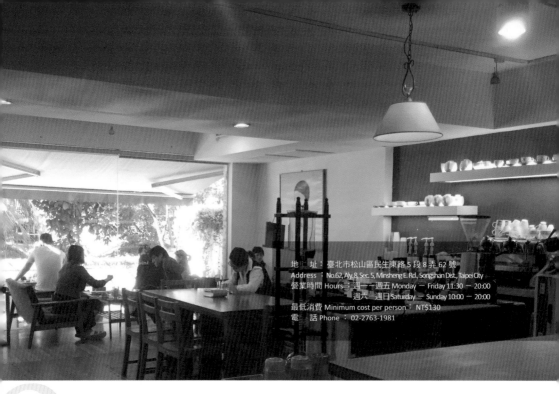

地　　址：臺北市松山區民生東路 5 段 8 弄 62 號
Address ：No.62, Aly. 8, Sec. 5, Minsheng E. Rd., Songshan Dist., Taipei City
營業時間 Hours ：週一一週五 Monday ─ Friday 11:30 ─ 20:00
　　　　　週六一週日 Saturday ─ Sunday 10:00 ─ 20:00
最低消費 Minimum cost per person： NT$130
電　　話 Phone ： 02-2763-1981

芭蕾咖啡館
Café Ballet ★★★★☆

This café only sometimes has a cat, although it has been around for many years and is popular both for the coffee and for the cat.

即便這家咖啡廳已經因為他們的咖啡與貓而聞名許久，但這家咖啡廳的貓只是偶爾才會出現一下。

Their afternoon tea special is buy a drink, add NT$25 and choose any dessert. The café has a pleasant atmosphere for working or studying and plenty of light. It's also convenient that they have fast free Wi-Fi and outlets by almost all of the tables.

他們的下午茶套餐是一杯飲料，加 NT$25 可以再選一樣甜點。咖啡廳裡光線充足、氣氛良好，相當適合工作或看書。Wi-Fi 很快，每張桌子也都有插座，所以非常方便。

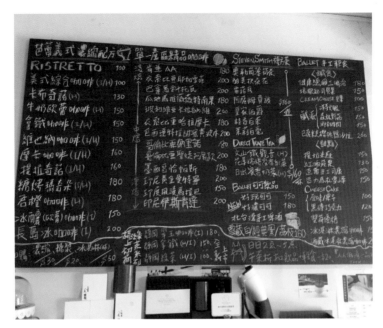

It's a nice café, but if you're in the neighborhood and want to see more cats, I'd recommend Spring Day Pet Café over this（P.190）.

這是一間好咖啡廳，但如果你在附近想看貓的話，我也很推薦小春日和寵物咖啡（P.190）。

地　　址：臺北市中正區忠孝東路二段 64 巷 6 號
（從忠孝新生捷運站二號出口走 500 公尺）
Address ：No.6, Ln. 64, Sec. 2, Zhongxiao E. Rd., Zhongzheng Dist., Taipei City（Go straight out of Zhongxiao Xinsheng MRT Exit 2 for about 500 meters）
營業時間 Hours ：週一一四、週日 12:00 － 20:00
Monday to Thursday, Sunday 12:00 － 20:00
週五一六 Friday － Saturday 12:00 － 21:30
最低消費 Minimum cost per person ： NT$110
電　　話 Phone ： 02 2341-9880

咖啡實驗室
Coffee Lab ★★★☆☆

This café has two cute, friendly cats. They have a wide variety of coffees and a few dessert items. They also sell individual packets of freshly ground coffee for NT$30, and you can also pre-order larger bags of coffee beans online.

　　這間咖啡廳有兩隻可愛又友善的貓。他們有許多種的咖啡和幾種甜點。店內的現磨咖啡每包 NT\$30，你也可以在網路上預購較大包的咖啡豆。

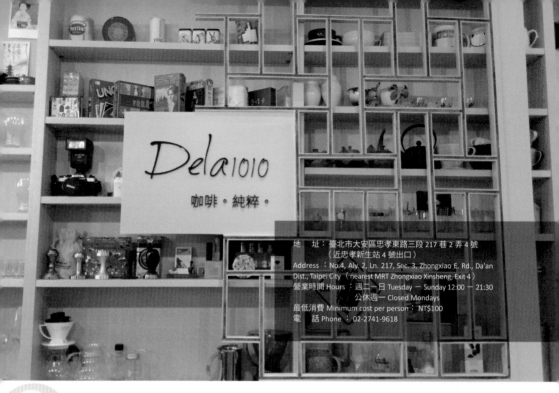

地　　址：臺北市大安區忠孝東路三段 217 巷 2 弄 4 號
　　　　　（近忠孝新生站 4 號出口）
Address ： No.4, Aly. 2, Ln. 217, Sec. 3, Zhongxiao E. Rd., Da'an
Dist., Taipei City （nearest MRT Zhongxiao Xinsheng, Exit 4 ）
營業時間 Hours ：週二一日 Tuesday ― Sunday 12:00 ― 21:30
公休週一 Closed Mondays
最低消費 Minimum cost per person： NT$100
電　　話 Phone ： 02-2741-9618

Dela 1010 ★★★★☆

This café sometimes has a beautiful Persian cat, but it's recommended to call first to see if it's there.

It has typical coffee and tea selections on the menu. They also have a wide variety of delicious desserts, displayed on postcards.

This café has a bright, relaxed atmosphere and is quiet enough for reading and studying. I'd also recommend it for the desserts.

　　這間咖啡廳偶爾會出現一隻很漂亮的波斯貓，但我建議先打電話來問看看牠在不在。

　　菜單上的咖啡和茶都很典型，明信片上還有許多種美味的甜點。

　　這間咖啡廳光線明亮、氣氛輕鬆，安靜的環境也很適合閱讀。我也很推薦他們的甜點。

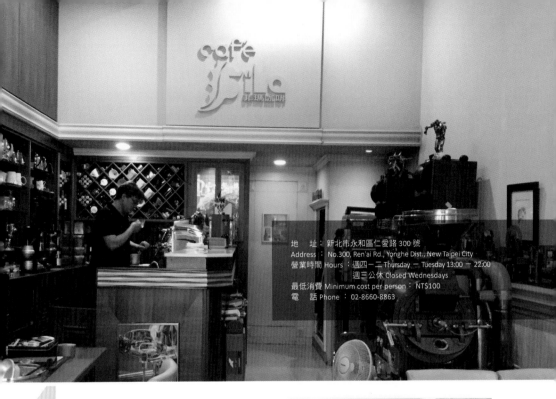

地　　址：新北市永和區仁愛路 300 號
Address ： No.300, Ren'ai Rd., Yonghe Dist., New Taipei City
營業時間 Hours ：週四一二 Thursday — Tuesday 13:00 — 22:00
週三公休 Closed Wednesdays
最低消費 Minimum cost per person： NT$100
電　　話 Phone ： 02-8660-8863

4

菲瑪咖啡
Café Fima ★★★★★

This café just has one cat, but it's definitely worth visiting. Its specialty is gourmet coffee and it is decorated with beautiful glass and metal coffee makers. There's also a violin on an ornate chair in the corner. The mahogany coffee bar gives the place a warm atmosphere, and it's a pleasant place to spend a quiet afternoon.

雖然這家咖啡廳只有一隻貓，但還是不容錯過。精品咖啡是這家咖啡廳的特色，裡頭裝飾著美麗的玻璃咖啡杯與金屬咖啡機，角落還有一張華美的椅子，上頭擺了一把小提琴。桃花心木製的吧檯賦予了這個地方一種溫暖的氣氛，讓人能在這裡愉快地渡過一整個下午的時光。

And even though it isn't exactly a cat-themed café, Cappu, an adorable blue-grey Scottish fold, is definitely the star. She's featured on the café's cleverly designed business cards. Customers can cut up the card and assemble their own 3D paper Cappu!

雖然說這裡不算是一間貓咪主題咖啡廳，但名為卡布的灰色蘇格蘭摺耳貓仍是店裡的明星，店裡精心設計的名片上也可

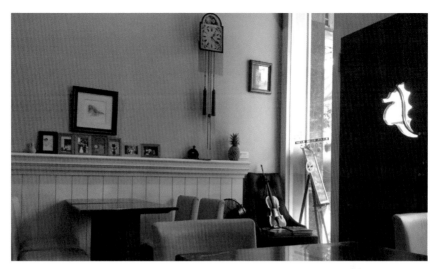

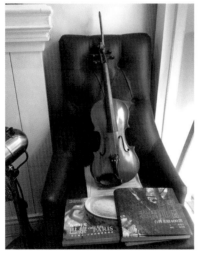

以看到她的身影。客人們還可以裁剪店裡
的名片，然後組合成一隻 3D 的卡布！

This café smells wonderfully of coffee
beans because they also grind and sell
bags of beans. They have a wide variety of
coffees from around the world to choose
from. A café Americano hot or iced is just
NT$100, and it doesn't cost extra to add
flavored syrup to it. Coffee with alcohol is
NT$150, and I had one with Kahlua.

咖啡廳裡有著美妙的咖啡豆香氣，因為
這家咖啡廳也會自己研磨並販售咖啡豆。
他們有來自世界各地的咖啡任君挑選，一
杯美式咖啡（冰／熱）只要 NT$100，加
糖漿不必另外加錢，但咖啡加酒的話要
NT$150，我就點了一杯卡魯哇咖啡酒。

貓店長的故事 Cat's story

The first time I went to this café, Cappu was asleep under a chair, but she later got up and sunned herself just outside the door. She has a relaxed personality and enjoys lying around and being the queen of the café. She tolerates being petted but won't often go up to customers.

The owner got Cappu from a friend when she was about five months old and now she's nine years old. She has a sleek grey coat and plump round face, and it's clear that she is well cared for. In some cat cafés, the cats live in the café all the time, but Cappu's owner takes her home with him every night.

　　我第一次來這家咖啡廳的時候，卡布在椅子下面睡覺，但後來她就起身到門外去享受日光浴了。她有著慵懶的個性，卻也享受著悠閒而身為咖啡廳女王的感覺。她能夠容忍人們撫摸她，不過她並不會經常主動去找客人。

　　卡布五個月大的時候，老闆從朋友那兒領養了她，現在她已經九歲囉。她有著柔順的灰毛以及豐滿的圓臉，看得出來她被照顧得很好。在某些貓咖啡廳裡，貓咪會一直住在咖啡廳中，不過卡布的主人每天晚上都會帶她一起回家。

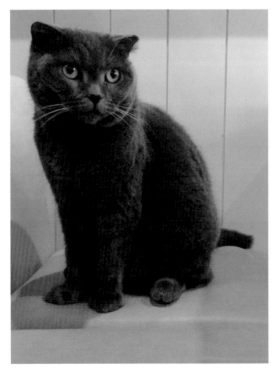

我的感想 My overall opinion

This café is a bit out of the way, a long walk from Dingxi MRT, and it took me a while to find it, but I was glad that I did. The coffee is excellent, the atmosphere is comfortable and the cat is lovely. She's the kind of cat that makes one feel content just to look at her.

這家咖啡廳有點遠，從頂溪捷運站出發大概要走一公里，也有點難找，但我認為這趟路走得很值得。咖啡很好喝、環境很舒服、貓咪很可愛，而卡布更是那種只要看著她就能讓人心滿意足的貓。

突點義大利美食咖啡館 Top Point 的貓店長

5 特選 / 好好吃
Excellent food

這些咖啡館都有很好吃的食物。 一些比較像餐廳、 一些有特別好的甜點。都有至少一隻貓， 但是沒有很多貓味主題裝飾。

These cafés are all good choices if you want good food. Some of them are more restaurants than cafés and some specialize in fine desserts. They all have at least one cat, but aren't exactly cat-themed.

地　　址：臺北市士林區中山北路 7 段 175 號
　　　　　（附近沒有捷運）
Address ：No.175, Sec. 7, Zhongshan N. Rd., Shilin Dist., Taipei City
　　　　　（No MRT nearby）
營業時間 Hours ：12:00 － 23:00
最低消費 Minimum cost per person：NT$120
電　　話 Phone ：02-2872-7790

Zabu

★★★★☆

The café has a nice atmosphere, with a good variety of music and artistic decorations. Before 5:30, they have the "afternoon tea" special, buy any drink and add a dessert for NT$60.

I've an iced americano and pumpkin pie, a dessert I don't often see in Taiwan. They also have inexpensive Japanese food and cocktails.

They have two resident cats who are often in hiding.

這家咖啡館的氣氛很好，音樂很好聽，裝潢更是充滿了藝術氣息。店裡在下午五點半之前提供下午茶套餐，點一杯飲料再加 NT$60 就有甜點。

我點過冰美式咖啡加南瓜派，南瓜派在
臺灣可不常見。店裡還有划算的日式料理
和調酒。

他們的兩隻貓常常躲起來，所以很難看
到牠們。

地　　址：臺南市中西區赤崁街 17 號
Address ：No.17, Chiqian St., West Central Dist., Tainan City
營業時間 Hours：週四—週一 Thursday — Monday 10:00 — 18:00
週二—週三公休 Closed Tuesdays and Wednesdays
最低消費 Minimum cost per person：NT$100
電　　話 Phone ：0955-261521

堆疊
Dui Die ★★★★★

This café's specialty is brunch and they have several delicious choices for NT$230-250. All the meals were presented on cutting boards. The potato wedges were especially good.

The café is right across from Fort Provintia and there's a good view of it from the window. I would recommend this café for its atmosphere and great food.

They have two beautiful cats who are rather aloof and spend most of their time on the first floor rather than in the dining area.

早午餐是這家咖啡廳的招牌，在 NT$230 到 NT$250 間有許多美味的餐點可供選擇，而所有餐點都是現點現做的。馬鈴薯角特別好吃。

咖啡廳的對面就是赤崁樓，從窗子望出去的景色也很棒。我會推薦這家咖啡廳是因為它的氣氛與美味的食物。

他們有兩隻美麗的貓，可惜的是牠們不喜歡靠近客人，牠們大部分時間都在一樓的櫃台附近，而不會上到二樓的用餐區。

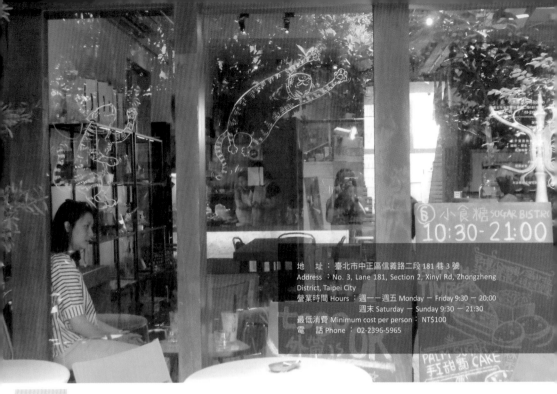

地　址：臺北市中正區信義路二段 181 巷 3 號
Address：No. 3, Lane 181, Section 2, Xinyi Rd, Zhongzheng District, Taipei City
營業時間 Hours：週一一週五 Monday — Friday 9:30 — 20:00
　　　　　　週末 Saturday — Sunday 9:30 — 21:30
最低消費 Minimum cost per person：NT$100
電　話 Phone：02-2396-5965

5 3. 小食糖
Sugar Bistro ★★★★☆

This café is in a traditional old building and has indoor and outdoor seating on two floors. The cat is cute and friendly and worth visiting.

The menu has a good variety of brunch and lunch options. I'd recommend the salmon omelette（NT$200）or the double mushroom 'burrito'（NT$180）, which is actually a pita. Another great choice is the berry smoothie which is huge and has lots of real strawberries and blackberries in it（NT$160）.

這家咖啡廳藏身於一棟老式的傳統建築中，兩層樓都有室內與室外的位置可供選擇。店

裡的虎斑貓很可愛，值得一來。

　　菜單上有許多種早午餐與午餐，我推薦鮭魚煎蛋捲套餐（NT$200）和雙香菇墨西哥捲（NT$180），雖然後者名為「墨西哥捲」，但它其實是「圓麵餅」，不過還是很好吃。我也很推薦他們的莓果冰沙（NT$160），很大杯，裡頭有滿滿的草莓跟藍莓，很好喝。

地　　址：桃園縣中壢市富州路 20 號
Address ： No. 20, Lanzhou St., Zhongli Dist., Taoyuan City
營業時間 Hours ： 11:30 — 22:00, closed Sundays 週日公休
電　　話 Phone ： 03-428-2972

突點義大利美食咖啡館
Top Point ★★★★☆

This is also more of a restaurant than a cafe, also Italian food. They have two cute cats that don't mind being petted, but keep their distance and don't jump on the tables. It seems like a lot of office workers come here on their lunch break, and reservations are recommended at this busy time. It has a quiet atmosphere and I saw several people using the Wi-Fi on their laptops.

這間店也有提供義式料理，看起來比較像餐廳。他們有兩隻很可愛的貓，可以摸摸牠們，但是牠們不會跳到桌子上。這裡在午餐時間有很多上班族會過來，常常客滿，所以午餐的時候要先訂位。這間店的氣氛比較安靜，因為店裡有 Wi-Fi，所以很多人會帶電腦過來辦公。

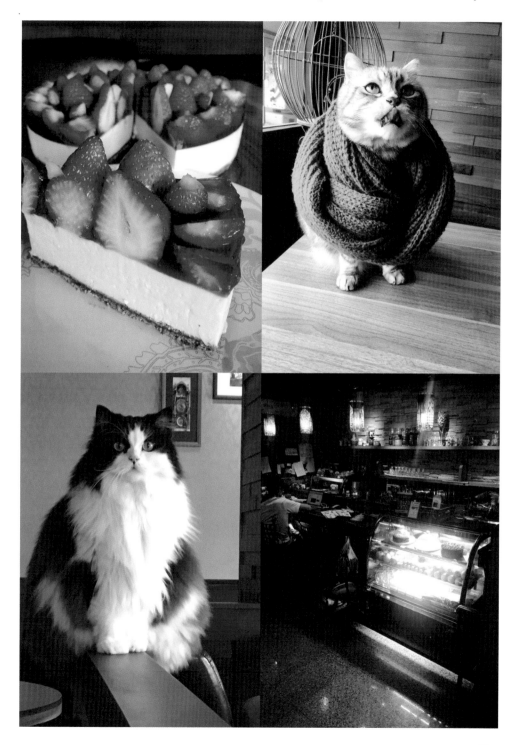

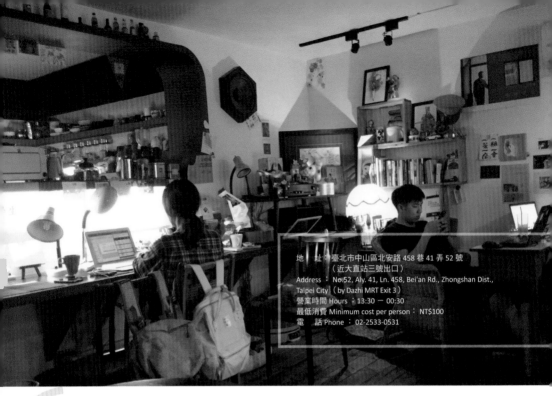

地　　址：臺北市中山區北安路 458 巷 41 弄 52 號
（近大直站三號出口）
Address ： No. 52, Aly. 41, Ln. 458, Bei'an Rd., Zhongshan Dist.,
Taipei City（by Dazhi MRT Exit 3）
營業時間 Hours ：13:30 ─ 00:30
最低消費 Minimum cost per person ： NT$100
電　話 Phone ： 02-2533-0531

6 杜鵑窩
Cuckoo's Nest ★★★★★

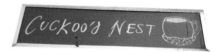

This cozy café has a great atmosphere: warm lighting, comfortable seats, books, nice variety of decorations and good mix of background music.

這家舒適的咖啡廳有著絕佳的氣氛：柔和的光線、舒適的座椅、書、多樣的裝飾品以及悅耳的音樂。

The first time I went, I thought they just had one cat. I paid my bill, but then the guy at the counter asked if I'd like to see the cats. He'd seen I had been taking pictures of the one cat. He said they had more than 30 cats upstairs!

So of course I said I wanted to see them and they were adorable. All of them are strays that they've taken in. Many of them

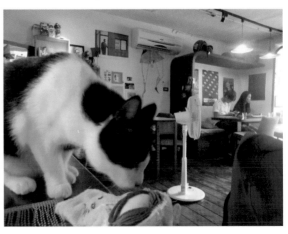

are available for adoption while others that are injured or otherwise unadoptable are well-cared for there.

當我第一次來的時候，我以為他們只有一隻貓。但在我付帳的時候，站櫃檯的那個人問我想不想看貓，他注意到我在拍貓的照片。他說他們樓上有三十幾隻貓！

我當然說想看，而牠們也真的超可愛的。這些貓以前都是流浪貓，然後被他們帶回來養。大部分的貓都開放領養，但有些受傷或不適合被領養的貓仍會在那裡受到妥善的照顧。

They have a wide variety of gourmet coffees and other coffee and tea drinks, as well as a small selection of desserts. Their specialty is a 'Whatever', which is a concoction of anything they choose.

The first time I ordered it, it was a latte with honey and cinnamon. Another time it was an Earl Grey latte with a bit of orange flavor and cocoa sprinkled on top. Anything

they make is delicious and I'd highly recommend ordering it.

他們有許多種精品咖啡，還有其他較一般的咖啡與茶飲，他們也有些許種類的甜點可供選擇。他們的招牌是「隨便特調」，真的是隨他們挑幾種出來調。

我第一次點的時候，我拿到一杯加了蜂蜜和肉桂的拿鐵。另一次則拿到一杯帶點橘子氣味、上頭還加了可可粉的格雷伯爵拿鐵。他們做的都很好喝，我強烈推薦，一定要點來試試看。

貓店長的故事 Cat's story

The cat who was there the first time I went has since passed away.

Now they have two other cats that they adopted more recently. DaTou is two year old black and white cat with striking golden eyes. Harry is a playful four year old orange cat. Both of them were found by customers and brought in to the café.

They get along very well and enjoy playing together. They are happy to be petted and will probably come up to inspect your bags.

我第一次來看到的貓已經去世了。

現在他們有兩隻最近領養的貓。大頭是一隻兩歲的黑白貓，牠有雙很漂亮的金色眼睛；哈利則是一隻四歲的橘貓，牠們都是被客人發現後帶進店裡來的。

牠們彼此很要好，也很愛玩在一起。除此之外，牠們很親人，有時還會跑來翻你的包包。

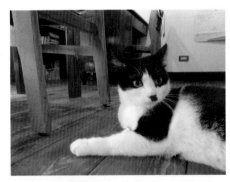

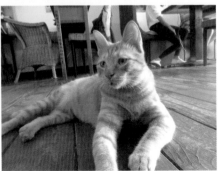

我的感想 My overall opinion

This café has a great atmosphere and excellent coffee. It's the kind of café I'd like to go to even if they didn't have cats. It's a good place to work, study or just relax. The two cats are very sweet, and it's nice to get the chance to visit the cats upstairs. I think it's a good idea to keep them separate, both for the cats and the people. Cats need time to get used to people and to each other, so it's better not to expose some stray cats to a café atmosphere right after rescuing them.

這家咖啡廳的氣氛跟咖啡都很棒，是那種即使店裡沒有貓我也願意去的咖啡廳。它是個絕佳的工作、讀書與放鬆的地點。兩隻貓很可愛，有機會能夠見到樓上的貓也很棒。我覺得不管是對貓還是對人來說，把貓跟人分開都是個很好的想法。畢竟貓不只需要時間來適應人，牠們也需要時間來適應彼此，所以最好還是不要把剛被帶回來的流浪貓馬上就放到咖啡廳裡。

路上撿到一隻貓 Le chat 的貓店長

7 特選 / 適合時尚與學生族群
Trendy / Student hangouts

這些咖啡廳都具有相當時尚、充滿藝術氣息的設計感，大部分都坐落於學生們經常往來的地方或是在商店街上。這些咖啡廳裡當然都至少有一隻貓，但並不見得每隻貓都很親人。如果喜歡時尚潮流的環境又希望有機會能看到貓，這些地方會是你的好選擇。

These cafés have modern, artsy designs, and most are in areas frequented by students or on shopping streets. They all have at least one cat, of course, but not necessarily a very friendly one. These are good places to go if you want a hip, fashionable atmosphere and the chance to see a cat.

地　　址：臺北市大安區溫州街 49 巷 2 號
Address ： No.2, Ln. 49, Wenzhou St., Da'an Dist., Taipei City
營業時間 Hours ： 每日 13:30 ─ 0:00, 建議先用電話詢問
Irregular, supposedly every day 13:30 ─ 0:00
recommend calling ahead of time
最低消費： 美式咖啡 NT$90
Minimum cost per person: Café Americano NT$90
電　　話 Phone ： 02-2364-2263

路上撿到一隻貓
Le chat ★★★★☆

This café is in the Gongguan/Shida area and appears to be popular with students and artistic types.

It's a bit dark, has beat up but comfortable furniture, and avant-garde decorations. Indie music is usually playing.

The menu has a wide variety of affordable options including coffee, teas and alcohol as well as light meals and snacks.

這家咖啡廳位於公館／師大區，看來很受學生與藝術家們的歡迎。

店裡有點暗，家具有點滄桑，不過還算舒適，裝潢倒是很前衛，店裡播的幾乎都是非主流的音樂。

菜單上有許多便宜的選擇，包括：咖啡、茶飲、酒，當然還有輕食與甜點。

There's only one cat inside, and I was warned to be careful because he sometimes bites. There's a smoking area outside and an orange cat hangs around out there. They have Wi-Fi and it's a good place to work or study as long as you like the music, which is a bit loud.

店裡只有一隻貓，店員還叫我要小心，因為牠有時會咬人。咖啡廳外面有吸菸區，有隻橘貓經常在那裡閒晃。店裡有Wi-Fi，如果你喜歡這裡的音樂又不嫌吵的話，這裡或許是個不論工作或讀書都不錯的好地方。

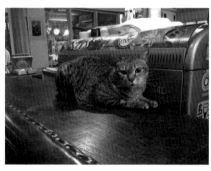

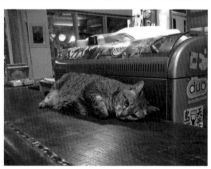

地　　址：臺北市大安區永康街 41 巷 26 號一樓
Address：1F., No.26, Ln. 41, Yongkang St., Da'an Dist., Taipei City
營業時間 Hours：週一一週五 Monday to Friday 12:00 － 0:00,
　　　　　 週末 Weekends 11:00 － 0:00
最低消費 Minimum cost per person：NT$130
電　　話 Phone：02-2391-2868

鴉埠咖啡
Yaboo café ★★★☆☆

Located on Yongkang Street, this cat café appears unremarkable among the other trendy cafés and restaurants in the area. And it is. Except for having two nice cats who were asleep, it's not really different from any other overpriced café in a popular shopping area.

The menu is typical without much variety. An Americano is NT$130, and a sandwich is NT$180.

They have two cute cats, one orange and one grey, but they were asleep the whole time when I went there.

在永康街上，跟其他鄰近的時尚咖啡廳
與餐廳相較之下，這家貓咖啡廳顯得不那
麼起眼，真的。除了有兩隻經常在打盹的
可愛貓咪之外，它和其他同樣在購物區的
高級咖啡廳十分相似。

菜單的樣式中規中矩，每杯美式咖啡
NT$130、三明治 NT$180。

他們有兩隻很可愛的貓，一隻橘色的、
一隻灰色的，但我到訪的時候牠們都一直
在睡覺。

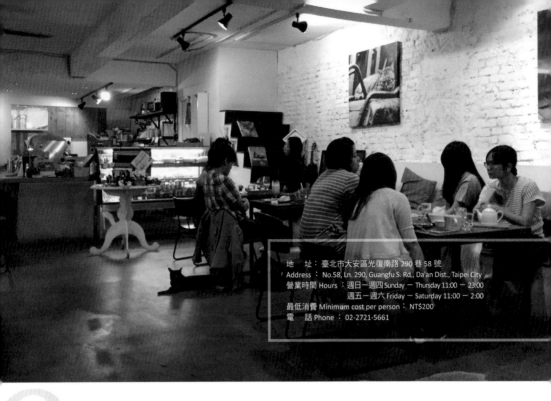

地　　址：臺北市大安區光復南路 290 巷 58 號
Address ：No.58, Ln. 290, Guangfu S. Rd., Da'an Dist., Taipei City
營業時間 Hours ：週日－週四 Sunday － Thursday 11:00 － 23:00
　　　　　　週五－週六 Friday － Saturday 11:00 － 2:00
最低消費 Minimum cost per person：NT$200
電　　話 Phone ：02-2721-5661

Toast Chat

★★★★☆

This café has five more or less friendly cats. They're young and active and constantly moving around. It has a comfortable atmosphere, with soft but not sleepy music playing, which makes it a good place to read or work.

這家咖啡廳有大約五隻友善的貓，牠們都年輕而好動，會一直在店裡走來走去。店裡的氣氛讓人覺得很舒服，音樂很柔和又不會讓人昏昏欲睡，很適合工作、看書或聊天。

The café is decorated with some cat themed pictures as well as with antiques. The wood floor and the furniture design gives it a vintage feel. There's an old sewing

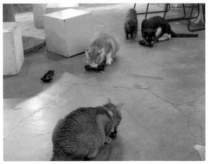

machine that's a favorite place for the cats to sit.

這家咖啡廳的設計很特別，裡頭有一些貓的主題圖片和古董，木製的地板與家具讓這家店充滿了古老的氛圍。貓咪們很喜歡坐在一台老舊的縫紉機旁。

With an NT$200 minimum per person, this café is a bit on the expensive side, but the food is delicious. French toast is one of their specialties and they also have many other brunch and dessert options. They also

have a wide selection of beer. I had banana caramel French toast （NT$160） with an Americano （NT$120）. I've also had an Oreo Frappuccino （NT$160）, which was delicious.

我覺得最低消費 NT$200 有點貴，但他們的食物真的非常好吃。法式吐司是他們其中一項招牌菜，他們還有許多種的早午餐、甜點和啤酒可以選擇，我試過他們的香蕉焦糖法式吐司（NT$160）和美式咖啡（NT$120），Oreo 冰沙（NT$160）也很好喝。

貓店長的故事 Cat's story

The princess of the café is Heibi, a sleek calico cat. She looks very proud of herself and the staff say that she can sometimes be bad-tempered, but she's very beautiful.

She was one of the first residents of the café, and they've had her since she was a kitten.

黑比是這家咖啡廳的小公主，她是一隻優雅的花斑貓。她看起來很驕傲，店員說她有時候脾氣不太好，但她真的很漂亮。

她是這家咖啡廳的「原住民」之一，從她還是小貓的時候就住在這裡了。

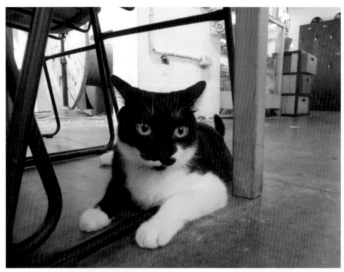

 我的感想 My overall opinion

This is a comfortable café with a unique, vintage atmosphere. Because it's an open area with high ceilings, it isn't particularly quiet, so it's not the best place to work or concentrate, but it's a good place to go with friends either for brunch or dinner. The cats wander around freely and while they don't usually especially seek out people, they don't mind being petted.

這家舒適的咖啡廳有著一種獨特而古老的氛圍。寬闊的空間加上挑高的天花板，稱不上是安靜，所以不能說是個適合專心或工作的地方，不過跟朋友們一起吃早午餐或晚餐的話，這裡倒是不錯。貓咪們會在咖啡廳裡自在地走動，牠們不會刻意主動找人，但牠們也不介意人們的撫摸。

鐵皮駅 Robot Station 的貓店長

9 特選 / 好設計
Cute design

這些咖啡館都有著可愛的設計，但不見得全部都是以貓咪為主題。可愛的小擺設、原創的家具、典雅的餐具或其他極具創意性的風格讓這些咖啡館顯得相當獨特。這些店裡最起碼都有一隻貓，但不一定都喜歡人，也不見得經常待在店裡。

All of these cats have cute designs though not necessarily cat-themed cute. They have cute knick-knacks, original furniture, elegant dishes or other creative touches to make them unique. All have at least one cat, but not always a friendly one or one that's always there.

地　　址：新竹縣尖石鄉新樂村拉號部落 11 鄰
Address ：11 Neighborhood, Lale Tribe, Xinle, Jianshi Township,
Hsinchu County
營業時間 Hours ：9:30 — 20:00
最低消費 Minimum cost per person：NT$100
電　　話 Phone ：0922-625383

紅薔薇
Roses villa ★★★★★

This is a large restaurant with beautiful gardens and a campground next to it in a rural part of Hsinchu county.

這裡是位在新竹農業區裡，一間很大的餐廳，裡面有美麗的花園，旁邊還有露營用的營地。

They have 12 cats in all, indoor/outdoor cats, so there are only a couple in the restaurant. Entry tickets to the park/garden area is NT$100. If you order from the restaurant, the ticket price is deducted from the bill. A few cats wandered around the restaurant. They weren't really interested in people, but seemed more interested in finding food.

The menu has a wide selection of options, and the food was ok. The atmosphere is what really makes it worth visiting though.

　他們養了十二隻貓，但大部分都在外面，所以餐廳裡大概只有兩隻左右。門票是 NT$100，如果在餐廳點餐的話可以折抵費用。餐廳裡面有幾隻貓在閒晃，但相較於人，牠們對於覓食還比較有興趣。

　菜單上有很多選擇，我覺得食物還算可以。讓人覺得值得一來的點在於他們的氣氛與風景。

地　　址：基隆市仁愛區孝二路 107 號 2 樓
Address ：No.107, Xiao 2nd Rd., Ren'ai Dist., Keelung City
營業時間 Hours：13:00 — 21:00
公休時間不固定，要先打電話問 call to confirm
最低消費 Minimum cost per person：NT$100
電　　話 Phone：02-2427-8438

黑兔兔的散步生活屋
Black Bunny Café ★★★★★

The style and decor in this café are very similar to Collection for Friends（P.100）. It's all vintage, country-schoolhouse style.

I ordered an Americano and waffle （NT$170）, and it was one of the most delicious waffles I've had! It was the perfect texture and toasted almonds and walnuts on top really added to it.

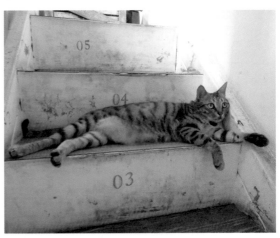

They only have one cat, Mochi, but he's definitely the center of attention. He's not at all afraid of people and enjoys admiration from a distance, but he bites, so don't pet him. I'd highly recommend this adorable café.

這間的設計跟私藏不藏私（P.100）很像，走溫馨鄉村風。

我點了美式咖啡和鬆餅（NT$170），而鬆餅超好吃的！鬆餅本身就很棒了，加上杏仁和胡桃更是讓人一吃就上癮！

他們只有一隻叫做麻糬的貓，而無疑地他是大家目光的焦點。他不怕人，似乎也很喜歡人家盯著他看，但是因為他會咬人，所以還是不要摸他比較好。我很推薦這間可愛的咖啡廳。

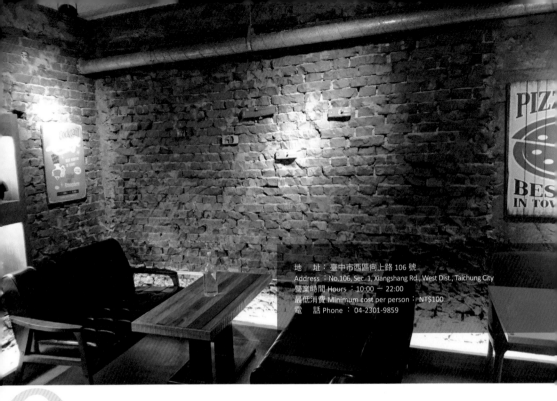

地　　址：臺中市西區向上路 106 號
Address：No.106, Sec. 1, Xiangshang Rd., West Dist., Taichung City
營業時間 Hours：10:00 － 22:00
最低消費 Minimum cost per person：NT$100
電　話 Phone：04-2301-9859

鐵皮駅
Robot Station

★★★★☆

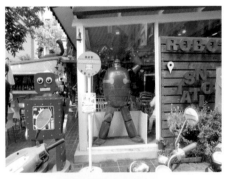

This café is more robot-themed than cat-themed, but they do have three fat cats, though I only saw one. Due to limited time and because it was crowded, I didn't actually eat or drink anything here, but they were nice enough to let me take pictures. It's very popular and probably worth another visit.

與其說這是家貓咖啡廳，倒不如說這是一家機器人主題的咖啡廳，不過他們真的養了三隻胖胖的貓，雖然我只看到一隻就是了。由於時間有限、人又多，我就沒有在那裡用餐了，但他們人很好，還是願意讓我拍照。這家店還滿受歡迎的，或許值得再去一趟。

地　址：新北市永和區仁愛路 279 號 1 樓
Address ： 1F., No.279, Ren'ai Rd., Yonghe Dist., New Taipei City
營業時間 Hours ：週二─週日 Tuesday ─ Sunday 13:00 ─ 22:00
週一公休 Closed Mondays
最低消費 Minimum cost per person：NT$100
電　話 Phone ： 02-2925-7699

日日村
A Day

★★★★☆

This cute café is close to Café Fima
（P.30）. It has wood floors, vintage
furniture and other old-fashioned
decorations. The menu has a variety of meal
choices; their specialty
seems to be Japanese
food, which is quite
reasonably priced. I just
ordered an iced Americano
（NT$110）.They also
sell postcards and other
cute knick-knacks, many of
them also Japanese style.
They only have one cat,
which was asleep in the
glass counter the whole
time I was there.

　　這間可愛的咖啡館離菲瑪咖啡（P.30）很近。有木頭地板、古老的家具、裝潢。菜單上有很多種選擇，他們的招牌似乎是日式料理，價格都算挺合理的。我只點了一杯冰美式咖啡 （NT$110）。他們也賣信片，還有可愛的日式小品。他們只有一隻貓，不過我在的時候，貓都在玻璃櫃檯裡面睡覺。

地　　址：臺北市信義區基隆路一段 147 巷 34 號之一
　　　　　（近市政府站 1 號出口）
Address：No.34-1, Ln. 147, Sec. 1, Keelung Rd., Xinyi Dist., Taipei City
　　　　　（near City Hall MRT exit 1）
營業時間 Hours：週二－週日 12:00 － 21:00
　　　　　週一公休 Closed Mondays
最低消費 Minimum cost per person：NT$110
電　話 Phone：02-2749-1219

小猴子咖啡
Café NO.218 ★★★★★

10

This is a small café near Taipei 101 featuring gourmet coffee, homemade food and two beautiful cats. It has soft jazz music playing and it's decorated with the work of local artists. Some of this work includes drawings of the cats. There's one wall that is decorated almost entirely with postcards, and some postcards are also available for sale.

這間在臺北 101 附近的小咖啡館有著高級咖啡、手工食物和兩隻很漂亮的貓。店裡播放著柔和的爵

士樂，裝飾著本土藝術家的作品，當中有些作品也包含了貓咪的畫。其中一面牆上幾乎貼滿了明信片，部分的明信片有開放選購。

膩咖啡」，那是一種口味偏重的冰咖啡，會加糖，上頭是綿密的奶泡。他們有好幾種套餐，冬天的時候還會有手工蔬菜湯。

The first time I went, I just had an Americano（NT$110）and that was good. They have a variety of gourmet coffees. I've also tried the 'Greek coffee' as I hadn't heard of that before. It's a strong iced coffee with sugar added and topped with thick, foamed milk. They also have a selection of meal sets, and in winter, homemade vegetable soup.

第一次去的時候，我只點了美式咖啡（NT$100），很不錯。他們有許多種的咖啡豆，我也嘗試了以往從沒聽過的「希

貓店長的故事 Cat's story

The first time I went to this café, only Bibi, a fluffy orange Persian was there. He's rather old, about 13 now, but he's still playful and energetic. I enjoyed watching him play in his water bowl.

The owner said that she adopted him from a friend who couldn't keep him anymore. He's a very relaxed cat who's happy to be petted.

Now there's also a new cat in the café named Dino. He has a face like a Persian

and ears like a Scottish fold. He's a bit shy because he is a rescue cat. He was abused and doesn't have any claws. When Dino first came, Bibi was upset, but now they tolerate each other well enough.

我第一次來的時候只有一隻叫做 Bibi 的可愛橘色波斯貓在，他大概十三歲，算有點年紀了，但他還是精力充沛、很愛玩。我喜歡看他在他的水盆裡玩。

老闆說，她是從一個沒辦法繼續養 Bibi 的朋友那邊將 Bibi 領養過來的。Bibi 很悠閒，也很喜歡人們摸他。

現在他們養了一隻新的貓，叫做 Dino。他的臉型有點像波斯貓，但他的耳朵卻像蘇格蘭摺耳貓。也許因為他以前是流浪貓的關係，所以有點怕生。他曾經受過虐待，所以他沒有爪子。當 Dino 剛來的時候，Bibi 很不爽，但是他們現在已經可以接受彼此的存在了。

我的感想 My overall opinion

I had a great first impression of this place because of Bibi and the friendly owner. He looks so fluffy and adorable rolling around on his back. The owner is very nice and willing to talk about the cats or make recommendations on the menu. The chairs are comfortable and they have Wi-Fi, so it's a pleasant place to work or study. They also have a good selection of unique postcards.

　　我對這家咖啡廳的第一印象很不錯，因為 Bibi 很可愛，老闆娘也很親切。Bibi 看起來毛茸茸的，當他用背在地上打滾時更是可愛極了。老闆娘人很好，很願意跟人談貓的話題或是推薦菜單上的食物。椅子很舒服，他們也有 Wi-Fi，所以是個絕佳的工作或讀書的場所。他們還有一些很特別的明信片。

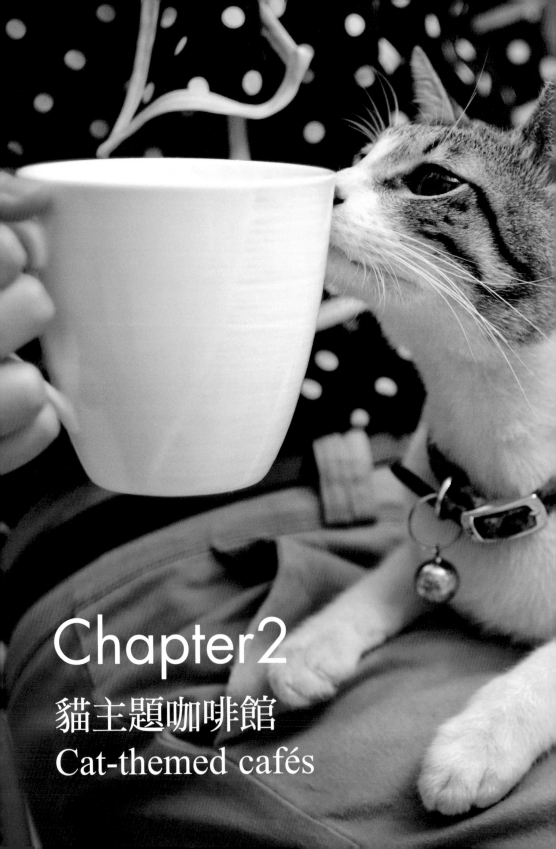

Chapter 2
貓主題咖啡館
Cat-themed cafés

地　　址：臺北市中山區長安西路 64 號
　　　　　（近中山站 4 號出口）
Address ： No.64, Chang'an W. Rd., Zhongshan Dist., Taipei City
　　　　　（Zhongshan MRT, Exit R4）
營業時間 Hours ： 週五─週六 Friday ─ Saturday: 11:00 ─ 22:00
　　　　　　　　 週日─週四 Sunday ─ Thursday 11:00 ─ 20:00
　　　　　　　　 週二公休 Closed Tuesdays
最低消費 Minimum cost per person：NT$60
電　話 Phone ： 02-2550-0561

1 貓妝
Mask Cat ★★★★★

This cozy café has only three cats, but they're very friendly and like curling up next to customers or sitting on their laps.

這家咖啡廳有三隻可愛的貓，他們都很親人，喜歡蜷伏在客人的身旁或是乾脆直接坐在客人的大腿上。

The café is filled with cat-related art work and has comfortable chairs and sofas and soft music playing, making it an ideal place to relax or study. Another excellent feature is that it has Wi-Fi and enough outlets to plug in computers.

咖啡廳裡到處都是貓主題的藝術作品，椅子、沙發都很舒服，再加上柔和的音樂，這裡無疑是個放鬆、看書的好去處。還有一個很棒的特點是，他們店裡有 Wi-Fi，也有足夠的插座能讓客人用電腦。

In addition to cat-related pictures on the walls, the walls themselves are also painted with cats. The owners did this artwork themselves along with some of the framed paintings and drawings. There are adorable cat knick-knacks all around, even in the bathroom.

牆上掛了與貓相關的圖畫之外，連牆上都畫滿了貓。是老闆自己畫的，看起來很有創意。包括廁所，整家店裡到處都是跟貓有關的可愛小物。

It has a wide variety of coffees and teas as well as light meal and dessert set choices. I've had an Americano （NT$80）, Earl

Grey tea （NT$100/pot）, cheesecake, lemon tart, berry tart, kimchee and cheese sandwich （each of these are NT$200, including a drink of a value of NT$150 or under）, all of which were very good.

他們有很多種的咖啡、茶飲，還有不少種輕食與甜點套餐可供選擇。我喝過他們的美式咖啡（NT$80）、格雷伯爵紅茶（NT$100），吃過他們的起司蛋糕、檸檬塔、莓果塔、泡菜起司三明治（下午茶套餐 NT$200），全都很棒。

They also offer coffee to go for only NT$60 and they sell a variety of fresh gourmet coffee beans. In the front of the store, they have a blackboard with all the kinds available and the prices.

你也可以外帶咖啡，外帶的話一杯只要NT$60，店裡也販售精品咖啡豆。店前面有個黑板，上頭寫著他們有什麼樣的咖啡豆和價格。

貓店長的故事 Cat's story

Maozai, a fat black cat who looks like she has eyebrows, is the oldest cat in this café and is quite happy with her position.

On a cold day, she is likely to sit on customers' laps. Sometimes, she might keep a distance and observe people while resting on one of the comfortable chairs, but if she sees someone pouring water, she will come over and check it out. If you let her, she'll drink it from the glass.

貓仔是一隻胖胖的黑貓，她的花色讓她看起來就像是有眉毛似的，她是店裡年紀最大的貓，而她似乎很享受自己現有的地位。

天氣冷時，她會坐在客人的大腿上。有時候她也會舒服地坐在椅子上，遠遠地觀察人們。不過當她看到有人在倒水的時候，她會走過來看，如果你允許的話，她還會從你的杯子裡喝水。

我的感想 My overall opinion

This was the first cat café I ever went to and it remains one of my favourites.

The first time I went, Maozai sat on my lap for about an hour. At that time, I didn't have cats of my own, and I think it's nice for people who don't have cats to be able come here and have the cats cuddle with them. The cats here are some of the friendliest out of all the cat cafés I've been to. It's a great place to bring my computer and spend a few hours working. And if I want to go to a café with a friend, I'll often recommend this not only because it's a cat café but also because of the nice environment overall.

這是我去過的第一間貓咖啡廳，而它至今仍是我最愛的一間。

我第一次去的時候，貓仔大概坐在我的身上足足有一個小時。在那個時候，我的房東不讓我養貓，我覺得沒有貓的人能來這裡享受貓咪的依偎是件很棒的事情。這裡的貓是我去過所有貓咖啡廳中最親人的。我很喜歡帶著電腦來這裡，然後工作上幾個小時。如果我想跟朋友去咖啡廳，我也總是會推薦這裡，不只是因為它是一家貓咖啡廳，更是因為它的環境。

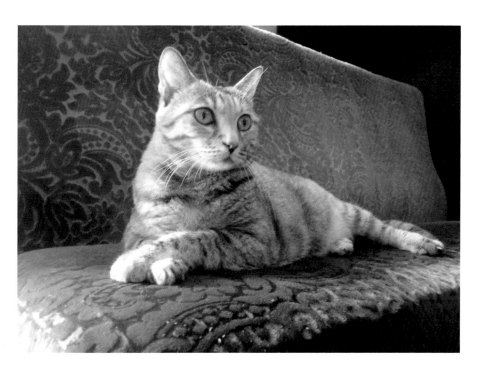

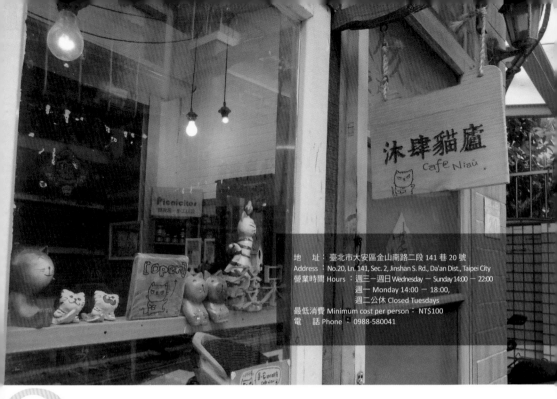

地　　址：臺北市大安區金山南路二段 141 巷 20 號
Address ：No.20, Ln. 141, Sec. 2, Jinshan S. Rd., Da'an Dist., Taipei City
營業時間 Hours ：週三—週日 Wednesday — Sunday 14:00 — 22:00
週一 Monday 14:00 — 18:00,
週二公休 Closed Tuesdays
最低消費 Minimum cost per person ：NT$100
電　　話 Phone ：0988-580041

2

沐肆貓廬
Café Niau ★★★★★

This tiny cat café has just one cat, but it also has cute cat-themed decorations and cat books for customers to read.

It's about halfway between Dongmen and Guting and is in an alley just across from Old' 98（P.172）, the cat bar. The café also sells homemade jams, jellies and sauces.

這家小小的貓咖啡廳只有一隻貓，但他們有著許多可愛的貓主題裝潢，還有跟貓有關的書供客人閱覽。

它大概在東門與古亭站中間，就在 Old' 98 貓酒吧（P.172）對面的巷子裡。這家咖啡廳也有賣手工果醬、果凍和醬料。

I had an iced Americano （NT$120） and read an interesting, humorous book （in English） on 'the maintenance of cats'. The coffee is good. I've also had a bagel with chocolate sauce. They always have a specialty jam or sauce of the day for bagels and the day I went it was chocolate.

我點了一杯冰美式咖啡（NT$120），看了一本有趣而幽默的關於貓飼育的書（英文的）。咖啡不錯。我還吃過巧克力醬貝果。他們每天都會為貝果搭配不同的果醬或醬料，我去的那天是巧克力醬。

貓店長的故事 Cat's story

The one cat is Milu, a grey tabby American shorthair that the owner has raised from a kitten. He's 10 years old and the café was opened in 2013, so he was with the owner long before the café opened.

He likes to stretch himself out in the middle of everything, unconcerned with what is happening around him. He doesn't mind being petted, but of course he doesn't want to be picked up. While he isn't overly fat, he has a sleek, well-fed look. He seems to know he's in charge of the place and that everyone is coming to see him, whether or not he deigns to recognize them.

貓店長叫做米魯，是一隻灰色的美國短毛貓。老闆從米魯還是小貓的時候就開始養他，現在米魯已經十歲了。咖啡廳是從二〇一三年開始營業的，而米魯早在那之前就陪伴著老闆了。米魯喜歡躺在咖啡廳中間的地板上，他也不介意人們摸他，但他討厭人們抱他。雖然他不胖，但是看起來胃口還是很好。他似乎知道自己是貓店長，知道大家都會愛他。

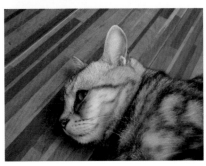

我的感想 My overall opinion

This cute little café is easy to miss in an out of the way place in a small alley, but it's worth a visit. I like sitting in the window where there are cute decorations hanging and where I can look out at passerby or look at Milu stretched out on the floor beside me. If you don't bring a book or a friend, there are plenty of entertaining books to stay occupied with. And while I haven't tried the jams and jellies, they're worth browsing as there are some unique flavors I haven't seen anywhere else.

這家咖啡廳很小，又在小巷子裡，所以很容易就錯過了，但我覺得它很有一去的價值。我喜歡坐在窗前的吧檯，那裡有著可愛的裝潢，我可以坐在那裡看著往來的行人，也可以看米魯在地板上伸懶腰。如果一個人來又沒有帶書的話，他們有很多有趣的書可以看。我沒有試過他們的醬料，但看起來很有趣，因為這些醬料都是我在別的地方從沒看過的。

地　　址：臺北市大安區和平東路三段 370 號二樓
Address ：2F., No.370, Sec. 3, Heping E. Rd., Da'an Dist., Taipei City
營業時間 Hours ：12:00 － 21:30
最低消費 Minimum cost per person ：NT$100
電　話 Phone ：02-2736-9898

3 讀貓園中途咖啡
Do Mao Yuan ★★★★☆

Located just before Linguang MRT station, this is a combination pet supplies store, cat café and cat hotel. The first time I walked past it, I thought it was just a pet supplies store as the narrow staircase going up to the second floor café can be easy to miss. The café has 4-5 friendly cats, which the helpful staff were eager to introduce.

這家店在麟光捷運站對面，它不只有賣寵物用品，還身兼貓咖啡廳與貓旅館。因為要經過狹小的樓梯上到二樓才會看到貓咖啡廳，所

以當我第一次經過的時候，我以為它只是家寵物用品店。咖啡廳裡有四、五隻可愛的貓，友善的店員很熱心地將牠們介紹給我。

They also have a separate, glass room with kittens to adopt. Regular customers can't go in without permission, but if you're interested in adoption, ask the staff and they'll let you have a supervised visit with the kittens.

他們還有一間獨立出來的玻璃房，待領養的小貓都在裡頭。一般客人在未經允許的情況下是不能進去的，如果你有意願領養，店員才會讓你進去。

The first time I went, I ordered a waffle set with Americano coffee （NT$150）. The presentation of the waffle is very cute. Another time I had the lasagna set （Garfield's favorite, according to the menu!）, which came with pudding and a drink. The lasagna wasn't bad though I think corn in lasagna is strange, but go to the café for the cats and atmosphere, not the food.

看起來很可愛。另一次去的時候，我點了千層麵（加菲貓的最愛！）套餐，套餐裡面還有布丁和飲料。雖然說千層麵本身還不錯，但我覺得千層麵裡頭有玉米有點奇怪，但我並非為了食物，而是為了貓和那邊的氣氛才去的。

This café does a lot to help stray cats. They take in kittens, get them their shots and put them up for adoption, and they also support TNR.

這家咖啡廳為了幫助流浪貓做了很多

我第一次去的時候，我點了鬆餅加美式咖啡的套餐（NT$150），鬆餅的外觀

事。他們領養小貓，替牠們打針，再安排牠們給人領養。他們也協助 TNR。

湯姆很活潑也很親人。我以為他在籃子裡睡覺，當我把我的娃娃放在他旁邊準備拍照的時候，他卻突然醒了過來，抓著我的娃娃玩得很瘋。

貓店長的故事 Cat's story

Not all of the cats are always in the main café area, but there are two who are there most of the time. They're brothers named Tom and Hank, and they've been at the café since it started. They are seven years old and were given up by their original owner.

Hank, a black and white cat, is more subdued. He likes people, but he prefers to spend his time relaxing and let them come to him rather than seeking them out.

並非所有的貓都在咖啡館裡，但有對兄弟檔幾乎是一直待在咖啡館裡，他們分別是湯姆與漢克。從咖啡館開張的時候他們就在了。原本的主人沒有辦法繼續養他們，所以老闆就接手領養了他們。

漢克是一隻黑白貓，性格比較沉穩。他喜歡人，但他更喜歡睡覺。他不會主動去找人，但人們可以摸他。

Tom is friendly and playful. I thought he was asleep in a basket, but when I put my doll by him to take a picture, he opened his eyes and started to bat at it, excited about this new toy.

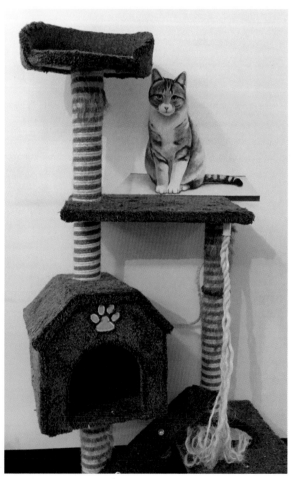

我的感想 My overall opinion

I like this café mainly because of what they do for stray cats. The whole place is very cat-centered—they make sure the resident cats and the foster kittens have a comfortable environment. Everything is reasonably priced and it seems like they focus more on helping cats than on making a profit. It's also a nice quiet place to read or work.

我喜歡這家咖啡廳主要是因為他們為流浪貓所做的事情。整家咖啡廳都是以貓為中心，他們希望原本在這裡的貓和後來領養的貓都能有個舒適的環境。東西的價格都很合理，他們似乎比較想幫助貓，而不是那麼在意營利。這裡也是個適合讀書或工作的好去處。

咕嚕咕嚕貓咖啡 Purr Café 的貓店長

4 特選 / 貓咪超親人
Friendly cats

這些以貓為主題的咖啡館都至少有一隻特別親人的貓，雖
然它們沒有排進我最喜歡的前幾名，但因為有貓，還是值
得一去。

All of these are cat themed cafés that have at least one
especially friendly cat. They didn't make my list of favorites,
but might be worth a visit just for the cats.

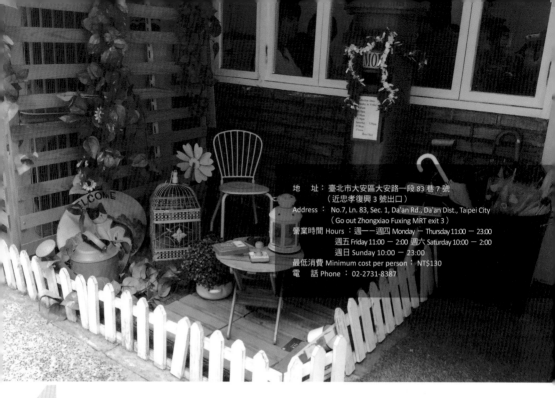

地　　址：臺北市大安區大安路一段 83 巷 7 號
　　　　　（近忠孝復興 3 號出口）
Address　：　No.7, Ln. 83, Sec. 1, Da'an Rd., Da'an Dist., Taipei City
　　　　　（Go out Zhongxiao Fuxing MRT exit 3）
營業時間 Hours：週一一週四 Monday ─ Thursday 11:00 ─ 23:00
　　　　　　週五 Friday 11:00 ─ 2:00　週六 Saturday 10:00 ─ 2:00
　　　　　　週日 Sunday 10:00 ─ 23:00
最低消費 Minimum cost per person：NT$130
電　　話 Phone：02-2731-8387

貓咪先生的朋友
Mr. Cat's friend

★★★★☆

This east district café is so popular that even on a Monday afternoon, the only free seat was at the bar. While I was there, I heard they kept getting calls for reservations.

They have four cats, the original Mr. Cat, known as Xiaoyang, and three other friendly cats. Mr. Cat seems to know that this is his café and spends most of his time on the bar, eating and watching people. I had a mocha frappuccino （NT$180＋10% service charge）. They also have sandwiches, waffles and specialty teas with fruit.

這間東區的咖啡館生意很好，週一下午只剩下吧檯前的一個空位。我在店裡的時候，一直聽到有人打電話來訂位。

他們有四隻貓，原本的貓先生，也就是小羊，還有其他三隻親人的貓。貓先生似乎知道自己是店長，他很喜歡坐在吧檯吃東西、看人。我點了摩卡冰沙（NT$180＋10% 服務費），他們還有三明治、鬆餅、水果茶。

WiFi Mr. cat's friend
密碼: mr.cat-mr.cat

Hot

黑糖奶茶
$180

組四張
100元唷月

MR.CAT
萬中選一
品所保證
浮雕立體
手機殼
這邊看吧!

☆ 貼♡小叮嚀
1. 請勿強行擁抱店喵
2. 店喵休眠時用眼看
3. 拍攝時勿開閃光燈

MR.CAT
I5/5S → 300
I6/6S → 350
6+/6S+ → 300
紙膠帶控

全新菜色

猫ちゃんの友達

地　　址：臺中市西區林森路 46 號
Address ：No.46, Linsen Rd., West Dist., Taichung City
營業時間 Hours：週一－週五 Monday － Friday 7:00 － 19:00
　　　　　　　　週末 Weekends 8:00 － 19:00
最低消費 Minimum cost per person： NT$40
電　　話 Phone ： 04-2371-9313

咕嚕咕嚕貓咖啡
Purr Café ★★★★★

This cozy Taichung cat café specializes in different varieties of coffee and its beautiful Scottish Fold cat.

They sell bags of fresh coffee as well as mugs featuring the cat. The menu has a wide selection of coffees and teas at quite low prices. An Americano is just NT$40. I had their specialty blend which is NT$60. They also have more gourmet varieties for up to NT$280. They also have sandwiches and waffles.

The cats are in a separate room. There are two of them–the Scottish Fold who is very friendly and is even happy to be picked up, and a grumpy gray tabby which supposedly bites. Maybe he's jealous that he isn't the star of the café. He's still a handsome cat.

　　這間位於臺中的貓咖啡館特點在於他們有許多種類的咖啡，還有一隻很漂亮的蘇格蘭貓。

　　店裡販售咖啡豆和蘇格蘭貓馬克杯。菜單上有許多種咖啡、茶飲，都還滿便宜的。美式咖啡只要 NT$40，我點的金牌特濃也只要 NT$60。他們還有三明治、鬆餅等食物。

　　店裡有兩隻貓，都在另外一個房間裡，其中一隻就是那隻蘇格蘭貓，牠很喜歡人們摸牠、抱牠；另一隻則是灰貓，牠比較兇、會咬人，牠可能是因為自己不是店裡的明星所以在嫉妒吧。但牠還是很帥。

地　　址：臺北市和平東路一段 184-1 號
Address：No. 184-1, Section 1, Heping E Rd, Da'an District, Taipei City
營業時間 Hours：7:00 — 22:00
最低消費 Minimum cost per person：NT$50
電　　話 Phone：02-3365-2865

貓圖咖啡
Cat.jpg ★★★★☆

This is definitely the smallest cat café I've been to, with only a narrow bar to sit at. It was crowded with students and annoying Japanese pop music was playing. But they have two adorable, friendly cats!

Another advantage of this café is that it's very cheap, with prices starting at NT$50. I had a green tea Oreo slushie for NT$75. They also have some cute cat decorations and sell pet products. It has everything a cat café should have in a quarter of the space for half the price. I'd also only want to spend about a quarter of the time I'd usually spend in one. But it's nice for students and people who want to check out a cat café quickly.

這家貓咖啡廳是我所見過最小的，他們只有一個小吧檯可以坐。裡面有很多學生，放著我不太能接受的日本流行音樂，但是他們有兩隻超可愛的貓！

這家的咖啡很便宜，最便宜的一杯只要 NT$50，我點的抹茶 OREO 冰沙也只要 NT$75。他們還有許多可愛的貓咪裝飾品，店裡也兼賣寵物用品。這麼小的店裡有這麼多的東西是很棒，但我沒在這裡待太久，不過對於學生或只想看看貓咖啡廳長什麼樣的人來說，這裡也許不錯。

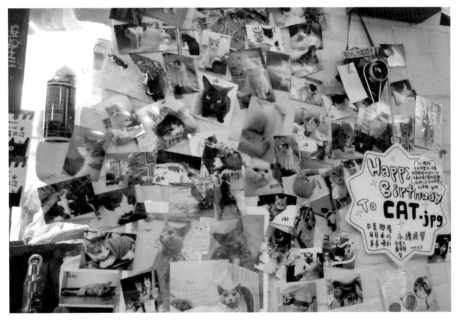

地　　址：台北市文山區指南路二段 56 號 2 樓
（近政大 / 台北動物園）
Address：2 F, No. 56, Sec. 2, Zhinan Rd., Wenshan Dist., Taipei City
(Near Chengchi University/Taipei Zoo)
營業時間 Hours：11:00 － 21:30
最低消費 Minimum cost per person：NT$50
電　話 Phone： 02-2939- 2790

4.4

小公寓
Apt. Café ★★★★★

This cozy café is near Chengchi University, the only cat café in this area. They also have a good variety of reasonably priced food and drinks. I had a French duck breast pita （NT$130） and an Americano （NT$60）.

They have four cats, though I only saw three of them. One white cat was curled up on a chair, happy to be petted. Two lively black cats ran around playing and happily came up to sniff my hand.

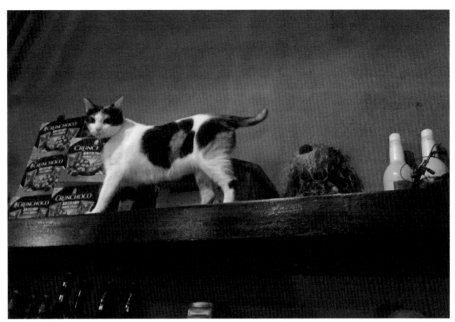

　　這間咖啡廳在政大附近，而政大附近也就只有這一間貓咖啡廳。他們的東西很好吃，價格也很合理。我點了法式鴨胸皮塔（NT$130）和美式咖啡（NT$60）。

　　他們有四隻貓，但我只看到三隻。其中一隻白色的貓睡在椅子上，牠很喜歡人們摸牠。另外兩隻是黑色的，也很喜歡靠近客人。

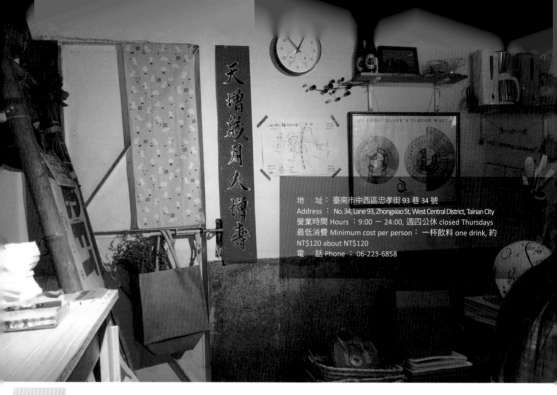

地　　　址：臺南市中西區忠孝街 93 巷 34 號
Address ： No. 34, Lane 93, Zhongxiao St, West Central District, Tainan City
營業時間 Hours ：9:00 － 24:00, 週四公休 closed Thursdays
最低消費 Minimum cost per person： 一杯飲料 one drink, 約
NT$120 about NT$120
電　話 Phone ： 06-223-6858

5

貓門咖啡
Café Moment ★★★★★

This Tainan café is located on a historical, brick-lined street in an area with lots of other cafes. The cafe is clean and brightly lit and is home to four cats. Three of the cats are friendly; the fourth spends a lot of time hiding in the upstairs storage area. Wi-Fi is available and there's plenty of seating.

　　這間貓咖啡店在台南一條古老的街裡，咖啡館很乾淨明亮。他們有四隻貓，其中三隻貓很親人，另外一隻大部分的時候都會躲起來。咖啡館有很多座位，還有提供 Wi-Fi。

From 9:00-13:00, they have a special brunch menu available with a variety of savory and sweet options that come with some small side dishes and a drink. I had a chicken curry sandwich, served with potato salad and a small cup of fruit and yogurt, and an Americano (NT$250).

他們 9:00-13:00 有提供早午餐菜單，有鹹的和甜的不同選擇，包含小菜還有飲料。我點過一份咖哩雞三明治，含小沙拉

和水果優格，還有美式咖啡 (NT$250)。

Both the meal and the coffee were very good. For the rest of the day, they serve the regular coffee and tea options as well as desserts. They also have a selection of beers available.

我覺得餐點都很好吃也很好喝。這裡全天供應咖啡、茶、甜點，晚上還有好幾種啤酒。

貓店長的故事 Cat's story

The cat "boss" of this café is Cola, a plump black cat who's three years old. He knows how to open the door himself and prefers to spend most of his time outside. He suns himself in front of the door and greets customers by walking up to them and rubbing on their legs. You may also see him enjoying himself on a motorbike, flexing his claws or taking a nap. The owner found him in the street when he was a young kitten and adopted him.

貓店長 Cola 是一隻胖胖的三歲黑貓。他會自己開門，很喜歡到外面溜搭。天氣好的時候，他會躺在門口歡迎客人光臨，也可能會看到他趴摩托車上，拉長他的趾爪睡午覺。他是在很小的時候，被老闆在路邊遇到而認養下來的。

Hana the calico and Vivi the grey and white tabby are about the same age as Cola and are also friendly. They stay indoors and are happy to be petted by whoever comes in. They were also adopted.

Hana 是一隻花斑貓，還有灰白貓 Vivi，他們跟 Cola 一樣都三歲。她們會留在店裡面顧店，很喜歡客人摸她們，她們也是被認養的。

我的感想 My overall opinion

The first time I went to this café, I went to their Kaohsiung store, which has unfortunately closed down since then. I went to see how this would compare and I wasn't disappointed. It has a pleasant atmosphere and adorable cats. It would be ideal for tourists to visit because of its central location, and for locals it would be a good place to study. It opens earlier than many cat cafes do, and the brunch is a good value.

我第一次拜訪時是在高雄店，我很喜歡，但是現在高雄店已經停止營業了。後來我在台南找到這裡，和原店很像，環境很好，貓很可愛。如果來台南欣賞文化、老街，很適合順道安排這裡，因為就在市中心。如果你住在附近，這裡很適合讀書、放鬆。他們營業時間比很多咖啡館早，早午餐很划算。

99

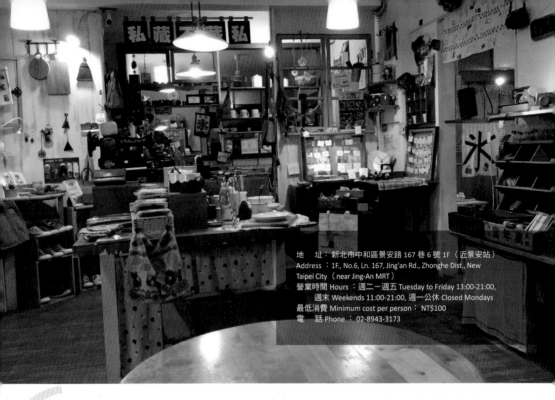

地　　址：新北市中和區景安路 167 巷 6 號 1F（近景安站）
Address ：1F., No.6, Ln. 167, Jing'an Rd., Zhonghe Dist., New
Taipei City（near Jing-An MRT）
營業時間 Hours ：週二－週五 Tuesday to Friday 13:00-21:00,
　　　　　　週末 Weekends 11:00-21:00, 週一公休 Closed Mondays
最低消費 Minimum cost per person：NT$100
電　　話 Phone ：02-8943-3173

6

私藏不藏私
Collection for Friends
★★★★★

This Zhonghe café, just a short walk from Jing-an MRT station, just has one cat, a fat, grey marbled one named Money. But it has such a cute design and so many cat decorations that I consider it a cat-themed café and not just a regular café with a cat. The café is quite popular, so reservations are recommended for meal times and weekends.

　　這家位於中和的貓咖啡廳離景安捷運站很近，他們只有一隻胖胖的灰白色貓，叫做 Money，但他們有許多可愛的設計和關於貓的裝飾，

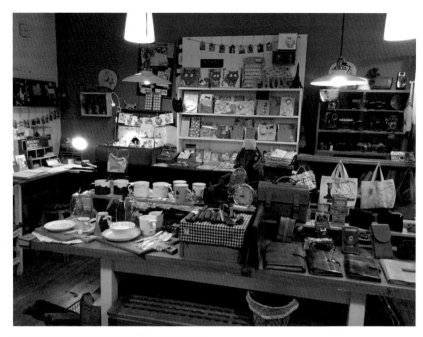

They also sell stationery, jewelry and other cat-related items, as well as high quality leather camera and phone cases.

店裡有可愛的裝潢，他們也賣文具與其他以貓為主題的東西，還有真皮的相機或手機套。

Their afternoon tea set is a great deal and really delicious, a drink （up to NT$100）, a cookie, and a waffle for NT$208. I've had a strawberry waffle and it came with strawberry cream, whipped cream and ice cream, and also a pancake filled with chocolate, banana and nuts, served with a tiny dish of ice cream. The coffee is served in a pretty cup with a cookie on a small saucer next to it.

這讓我想稱它為貓主題咖啡廳，而非一般有養貓的咖啡廳。很多人喜歡這裡，所以如果是週末要來用餐的話，我建議先訂位。

The regular meal choices are also extensive and quite good. It seems like each time I go, their menu is expanding, and as it's in a binder, it's easy for them

to add photos and descriptions of the menu items.

他們的下午茶很划算又很好吃，套餐的內容包括：飲料（NT$100 以內）、餅乾和鬆餅，這樣 NT$208。我點了一個草莓鬆餅，上頭有草莓奶油、生奶油和冰淇淋，還有放滿了巧克力、香蕉和堅果的煎薄餅，以及裝在小碟子裡的冰淇淋。咖啡則是裝在一個漂亮的杯子裡，旁邊還有一塊小餅乾。

商業套餐也有很多選擇，看起來都很好吃。感覺好像我每次來都會有新的餐點，因為菜單是用活頁夾做成的，所以他們就一直加新的東西進去，裡面也都有照片。

🐈 貓店長的故事 Cat's story

Money is a chubby, marbled tabby American shorthair. The owner got him as a kitten from a friend who raises the breed. Now he's about eight years old. He's a very laid back cat and can often be seen sleeping peacefully.

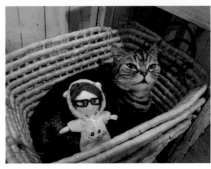

He likes to be petted, but he's afraid of small children, so if the café is quite busy, he may be hard to find. The staff say he's most active when they first open and later in the evening.

Money is featured on the business cards and the owner regularly updates them with new photos based on the season, for example, putting Money in a Santa suit at Christmas.

Money 是一隻胖胖的灰白色美國短毛貓。牠剛出生沒多久就被老闆從朋友那邊領養來，現在大概已經八歲了，是隻很悠哉的貓，人們會常常看到牠睡得很開心。

牠喜歡人們摸牠，但牠很怕小孩，所以當店裡在忙的時候，牠很可能會躲起來。店員說牠早上和晚上的時候最活潑。

店的名片有 Money 的照片，老闆每一季都會換名片，同時也換上不同的照片，冬天的名片會有 Money 打扮成聖誕老公公模樣的照片。

 我的感想 My overall opinion

I loved this place from the moment I walked in it because of the adorable decorations. It has a vintage feel, with the furniture like something from an old schoolhouse. It's a great place to go with friends or to bring a computer and work. And while Money isn't the most affectionate cat, it's calming to watch him sleep and see how content he is.

打從我第一次來，就很喜歡這間咖啡館，因為它的裝潢很可愛，又帶著一種復古風，家具給人置身在以往的學校的感覺。很適合帶朋友一起來，也很適合一個人帶著電腦在這裡工作。雖然 Money 不是很親人，但看牠安詳地睡著讓我覺得很放鬆。

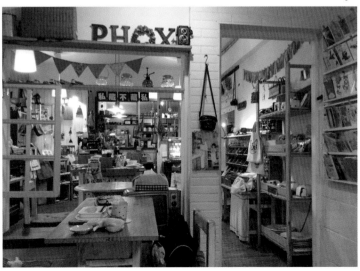

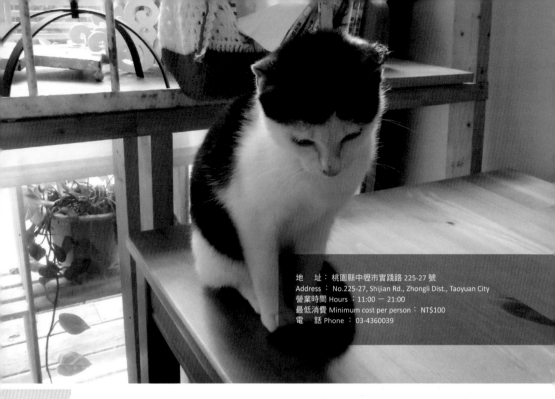

地　　址：桃園縣中壢市實踐路 225-27 號
Address： No.225-27, Shijian Rd., Zhongli Dist., Taoyuan City
營業時間 Hours：11:00 — 21:00
最低消費 Minimum cost per person： NT$100
電　話 Phone： 03-4360039

7 設計義式品嚐館
Design Fever ★★★★★

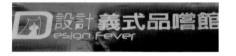

This café/restaurant is in Zhongli, near Chung Yuan Christian University. It has some of the friendliest cats of all the cafés that I've gone to. They come up to people and are happy to sit on their laps. I've noticed quite a few people bringing young children and the cats seem to get along well with them. They have at least five cats and sometimes more. In the summer, they take in kittens from the pound and put them up for adoption.

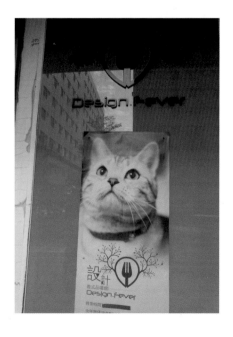

　　這間咖啡館／餐廳在中壢的中原大學附近，他們的貓都很親人，願意靠近客人，也會坐在客人身上。我發現有些人會帶小朋友來，而貓咪對孩子們也很有耐心。店裡至少有五隻貓，偶爾會更多，夏天的

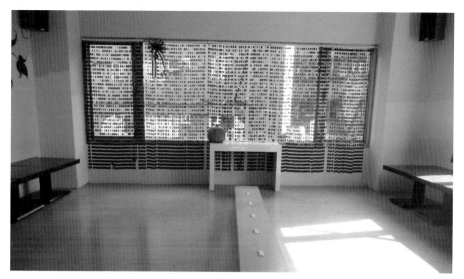

時候，他們會從收容所將小貓帶來咖啡館
裡，讓人們領養。

It has two floors, and the cats can be up
or downstairs, usually wherever the most
people are. Upstairs there's an area in the
middle of the floor with lots of outlets, and
Wi-Fi is available throughout.

這家咖啡館有兩層樓，貓大部分的時候
都在人最多的那一層，樓下的大空間有很
多插座，整家店都收得到店家提供的 Wi-
Fi。

It's actually more of a restaurant than a
café, with a variety of Italian food on the
menu. Pastas are NT$200-$250 （includes
drink of NT$100） and pizzas are NT$200

（doesn't include drink）.

Most drinks are NT$100, and they also
have several larger set meals for a few
people to share.

The first time I went, I ordered a pizza
and rose tea. The pizza was huge! It was
good, but I couldn't eat it in one sitting. A
kitten wanted to help me. I've also had a
chocolate waffle （NT$120） and a latte
（NT$120）. I'd recommend the pizza over
the waffle.

其實這家咖啡館比較像餐廳，他們有許
多義式料理，義大利麵大概在 NT$200 到
NT$250 之間，裡面還含了 NT$100 的飲
料，披薩 NT$200，但不含飲料。

大部分的飲料都是 NT$100，他們還有
份量比較大的套餐，可以讓二到四個人分
著吃。

我第一次去的時候點了披薩和玫瑰
花茶，披薩的份量超大！很好吃，但我
一個人吃不下，小貓還想幫我吃呢！我
還點過巧克力鬆餅（NT$120）和拿鐵
（NT$120），但我比較推薦披薩。

貓店長的故事 Cat's story

The first café cat was Laopi, a fat marble tabby. They got him when he was a kitten from a friend whose cat had had kittens. Now he's about nine years old. He loves to curl up on people's laps and jump on the counter to observe what the staff are doing.

第一隻貓店長是老皮，牠是一隻胖胖的灰白色虎斑貓。在牠還很小的時候，老闆就從朋友那裡領養了牠，牠現在大概九歲了。牠很喜歡坐在客人身上，也很喜歡跳上吧檯看店員工作。

After Laopi, they adopted more cats over time, from people who found them as strays or who couldn't keep them anymore. To encourage more people to adopt, they take in kittens sometimes so that people might see them in the window and want to adopt them.

Having kittens in the café also gives them a chance to get used to people at a young age so they'll be more adoptable.

在老皮之後，他們又陸陸續續領養了其他的貓，可能是流浪貓，也可能是主人沒辦法繼續養的。他們希望有其他人能夠領養貓，所以偶爾也會看到小貓出現在店裡，人們可以透過窗戶看到小貓。

讓小貓待在咖啡廳裡也能讓牠們從小就習慣人們的存在，讓牠們更適合被人們領養。

 我的感想 My overall opinion

I've been to this café twice, and made a special trip to Zhongli from Taipei both times. Of course, I'm obsessed with going to every cat café, but it really is worth a visit because the cats are so sweet. I'd recommend taking a taxi from the train station rather than try to follow Google's walking directions, though, as it's a bit difficult to find.

我去過這家咖啡廳兩次,兩次都是特地從臺北跑到中壢。我當然希望能多造訪幾家貓咖啡廳,但我真的覺得這間很值得去,因為他們的貓特別親人。我建議從火車站搭計程車去,因為走路的話實在有點難找。

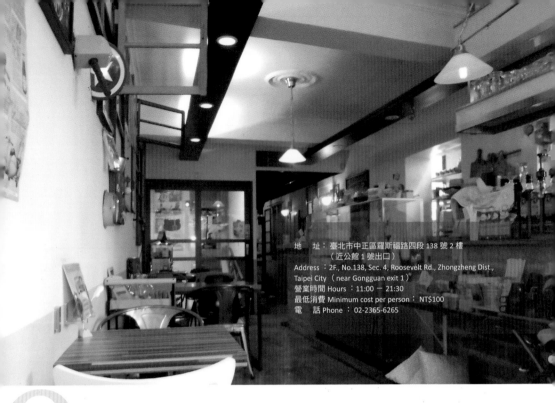

地　　址：臺北市中正區羅斯福路四段 138 號 2 樓
　　　　　（近公館 1 號出口）
Address ：2F., No.138, Sec. 4, Roosevelt Rd., Zhongzheng Dist.,
Taipei City（near Gongguan exit 1）
營業時間 Hours ：11:00 － 21:30
最低消費 Minimum cost per person：NT$100
電　　話 Phone：02-2365-6265

8 迷路迷路
Minou Minou ★★★★★

The café has a quiet, cozy atmosphere with decorations with cats on them as well as accessories for cats, like a record player scratching pad. They have cat-themed books and magazines for customers to read and also sell paw-shaped mugs（the coffee is also served in these mugs）.

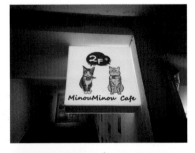

這家咖啡廳的氣氛很棒，有以貓為主題的裝飾，像是電唱機，還有貓用品。他們有以貓為主題的書和雜誌供客人閱覽。他們還有賣很特別的貓爪子馬克杯（店裡就是用這種馬克杯）。

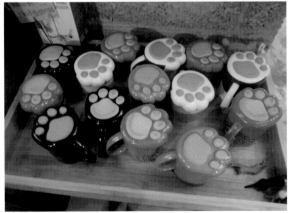

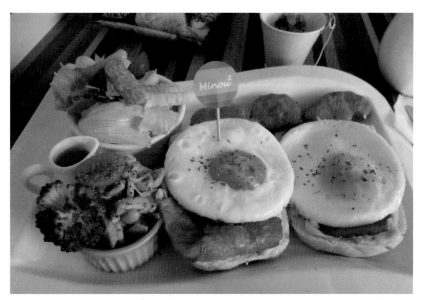

A delicious smell of bacon and coffee fills the café. Their specialty is brunch, but they also have sandwiches, desserts and full dinner options （served after 4pm）. I've tried several of the brunch sets, which come with black tea （NT$250-$290）. I'd recommend the Italian one or the Minou classic. The food is delicious and has a cute presentation with little toothpicks with cat stickers.

當你一踏進店裡，你就會聞到美好的培根與咖啡香味。早午餐是他們的招牌，不過他們也有三明治、甜點以及晚餐（下午四點過後）。我點過幾種含紅茶的早午餐套餐，價格從 NT$250 到 NT$290 不等。我推薦 Italy 牛肉丸歐姆蛋套餐和 Minou 經典餐盤，食物很好吃，看起來也很可愛。他們的牙籤上面還貼了貓貼紙。

貓店長的故事 Cat's story

They have two cats, Paopao and Dibao. Both of them were adopted. Dibao is the youngest and the friendliest. The first time

I visited he was still a kitten. They got him from someone who found him on the street when he was just a couple of months old. He's a brown tabby with a white chest and he looks like he's wearing a suit. The big red bow tie he wears around his neck adds to this impression. He loves playing with toys, and when he's sleepy, he curls up on customers' laps.

他們有兩隻貓，泡泡和弟寶。他們兩隻都是領養來的。弟寶比較小，也比較親人。我第一次去的時候他還是小貓。他才幾個月大的時候，人們在路旁發現了他，於是老闆便領養了他。他是一隻咖啡色的

虎斑貓，但胸前是白色的，看起來就像是穿著西裝一樣。他還戴著一個紅色的領結，非常可愛。他很喜歡跟玩具玩，當他想睡覺的時候，他會睡在客人的大腿上。

Paopao is more aloof, but she will let people pet her. She's a grey marble tabby, a mix of American shorthair and chinchilla. She can usually be found on a stool near the bathrooms or in her little 'house' near the 'record player'.

泡泡不太愛理人，但她還是願意讓人們摸她。她是一隻灰白色的虎斑貓，是美國短毛貓跟金吉拉的混血。她常常睡在廁所旁的椅子上，要不然就是在電唱機旁她的「小屋」裡。

 我的感想 My overall opinion

This café has a cozy, comfortable atmosphere and a convenient location. It's a great place to go for brunch, to go with friends or to bring a computer or book. Dibao is adorable, especially if he chooses to sit on your lap. I have too many cat mugs already; if I didn't I would probably buy one because the paw design is one of the cutest I've seen.

這家店的氣氛很舒服，地點也很方便，是個吃早午餐的好去處。適合帶朋友去，也適合帶書或電腦去。弟寶很可愛，當他選擇坐在你的大腿上時更是讓人覺得超幸福的。他們的馬克杯是我見過最可愛的，要不是我已經有太多貓馬克杯了的話，我真的好想再買一個。

肥貓故事館 Fat Cat's Story 的貓店長

9 特選 / 好有形
Cute decorations

The cafes in this section all have lots of adorable decorations and knick-knacks.

這些店都有很多可愛裝飾。

地　　址：臺南市中西區神農街 135 號
Address：No.135, Shennong St., West Central Dist., Tainan City
營業時間 Hours：14:00 － 22:00
最低消費 Minimum cost per person：NT$80
電　　話 Phone：06-220-5688

肥貓故事館
Fat Cat's Story ★★★★☆

 This café in Tainan only has two cats, but it's very cute and definitely worth going to. It has photographs taken by the owner and other cat related exhibits by artists and design students. One of the cats is very friendly and sits in customers' laps. The other one is shy and spends most of its time hiding in the kitchen. The menu was simple, basic coffee drinks and also fresh-baked desserts. I just had an Americano, which was good.

這家位於臺南的咖啡館只有兩隻貓，但
非常可愛，絕對值得你走一趟。店裡有老
闆拍的照片，還有其他設計系學生、藝術
家做的關於貓的東西。其中一隻貓很喜歡
坐在客人身上，另外一隻就比較害羞，經
常躲在廚房裡。菜單很簡單，是一般的咖
啡和手工甜點。我點過他們的美式咖啡，
很好喝。

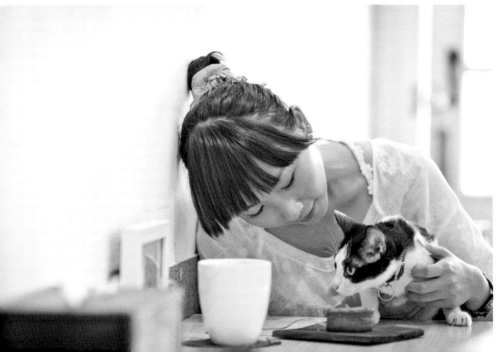

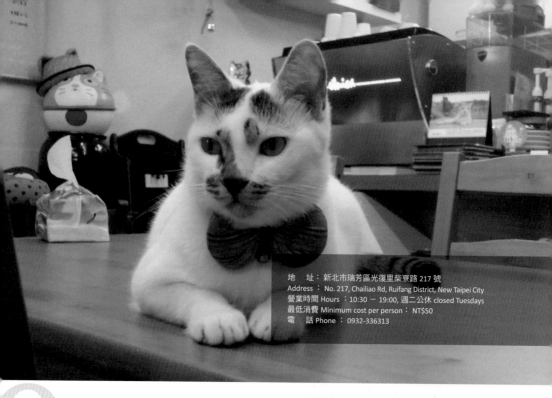

地　　址：新北市瑞芳區光復里柴寮路 217 號
Address：No. 217, Chailiao Rd, Ruifang District, New Taipei City
營業時間 Hours：10:30 － 19:00, 週二公休 closed Tuesdays
最低消費 Minimum cost per person：NT$50
電　　話 Phone：0932-336313

217 咖啡
★★★★★
Houtong 217 Café

Almost all the shops and cafés in Houtong have cats coming in and out, but this is the best one. They have three beautiful cats that are there all the time. The menu has all the typical café items at low prices, with coffee and tea starting at just NT$50. I had a citrus tea for NT$80 and it came in a very cute cup. They have lots of other cute cat decorations and also sell other cat-themed items including postcards and jewelry.

大部分在侯硐的咖啡館和店家裡都會有貓跑來跑去，但我覺得這間是最棒的。他們有三隻漂亮的貓，而且牠們幾乎都會一直在店裡。菜單上有飲料和簡餐，都很便宜。像美式咖啡和紅茶都只要 NT$50，我點的金桔檸檬茶也只要 NT$80。他們的杯子很可愛，店裡還有許多可愛的裝飾，他們也賣以貓為主題的東西。

地　　址：臺中市西屯區大墩 18 街 130 號
Address ：No.130, Dadun 18th St., Xitun Dist., Taichung City
營業時間 Hours ：11:00 － 21:30
最低消費 Minimum cost per person ： NT$80
電　　話 Phone ： 04-2320-7799

喵喵廚房
Yu Kitchen

★★★★☆

This quaint café is decorated in the style of an old-fashioned country kitchen. They have lots of cute decorations, but the three cats are kept in a separate area away from the tables. They have a variety of brunch, dessert and light meal options, coffee and tea, and juice drinks. I had a raspberry yogurt drink （NT$90）, which was very good. This café also has Wi-Fi and plenty of plugs for computers or chargers.

這家可愛的咖啡館氣氛很棒，有許多可愛的裝飾，但是他們的三隻貓都在另外一個房間裡。他們有很多早午餐、點心、簡餐、咖啡、茶和果汁，

我點的木莓酸奶（NT$90）就很好喝。這間有很多插座，店裡也提供 Wi-Fi，用起電腦來十分方便。

地　　址：臺南市中西區信義街 114 號
Address ： No.114, Xinyi St., West Central Dist., Tainan City
營業時間 Hours ：週日－週四 Sunday ― Thursday 11:00 ― 19:30
　　　　　　　週五－週六 Friday ― Saturday 11:00 ― 20:30
　　　　　　　週三公休 Closed Wednesdays
電　話 Phone ： 0983-788010

Fat Cat Deli

★★★★☆

This Tainan café is located on Xin Yi Street, a quiet street full of old buildings. Fat Cat Deli is at the far end of the street near a small temple. One cat occupies a place of pride on the owner's record player, and is quite happy to be stroked while you order your coffee. The first area in the café is the bar, where you order. The detailed menu offers many different kinds of coffee, as well as sandwiches, biscuits and cakes. Adjoining this is the main seating area. The third area leads off from the bar up an extremely narrow staircase. Here, you will find a sunlit room with two more cats. It has comfortable seating for about 5 people, as well a deck, a back balcony and a large window. It's well worth going up to take a look, not only to see the other cats, but also to get an idea of traditional Tainan housing.

　　這間臺南的咖啡廳位在信義街，那是一條恬靜而有著許多古老建築的街道。其中一隻貓喜歡坐在老闆的電唱機旁，牠很喜歡人們在點餐的時候摸摸牠。菜單上有許多種咖啡、三明治、餅乾和蛋糕。吧檯就是點餐區，另一個房間則是用餐區，上到二樓還有五人的座位和另外兩隻貓。如果來了，一定要到二樓去一趟，不僅可以看貓，更可以欣賞臺南古老的建築設計。

地　　址：臺北市大同區南京西路 18 巷 6 號 2 樓
　　　　　（近中山站 1 號出口）
Address ： 2F., No.6, Ln. 18, Nanjing W. Rd., Datong Dist., Taipei City
　　　　　（ near Zhongshan MRT exit 1 ）
營業時間 Hours ：不一定，去之前建議先打電話
　　　　　Whenever they want
最低消費 Minimum cost per person ： NT$90
電　　話 Phone ： 02-2552-7819

雙倍喜歡
Double Like ★★★☆☆

This is a relatively new cat café in the Zhongshan area. They have regular hours posted on a sign, but don't believe it. Their hours are very irregular and the whole place is sometimes booked for private events.

The design and decor are very cute. I especially like the way the walls are painted. Their specialty is spaghetti. I got a set meal, spaghetti with pesto sauce and clams, the dessert of the day （blueberry cheesecake） and coffee （NT$309）. The food and the coffee were very good. This café is nice if you're lucky enough to be in the area when it's open or perhaps if you want to book a party here. I wouldn't make a special trip here without calling. And it's also not a good place to work as they don't have Wi-Fi.

　　這是中山站附近一家相對較新的貓咖啡廳，他們外面的牌子上有寫營業時間，但他們的營業時間很不固定，偶爾還會被客人包場。

　　店裡的設計、裝潢都很可愛，牆上畫的圖片讓我覺得很特別。他們的招牌是義大利麵，我點了一份套餐：青醬義大利麵、藍莓起司蛋糕加上美式咖啡，都滿不錯的，這樣 NT$309。如果你想來這裡的話，建議先打電話問看看他們有沒有開。店裡沒有 Wi-Fi，想在這裡用電腦的話並不是那麼方便。

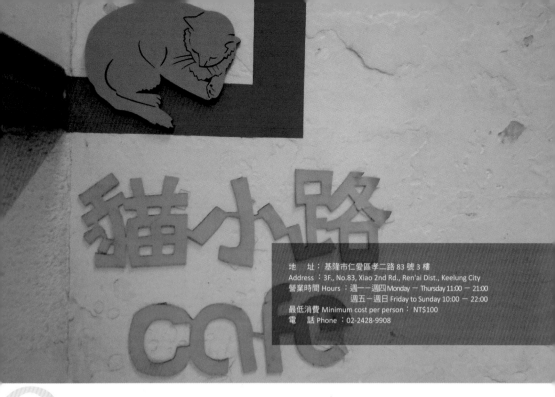

地　　址：基隆市仁愛區孝二路 83 號 3 樓
Address ：3F., No.83, Xiao 2nd Rd., Ren'ai Dist., Keelung City
營業時間 Hours ：週一—週四 Monday — Thursday 11:00 — 21:00
週五—週日 Friday to Sunday 10:00 — 22:00
最低消費 Minimum cost per person ： NT$100
電　　話 Phone ：02-2428-9908

貓小路
Nekokoji Café ★★★☆☆

This Keelung café is conveniently located just a few hundred meters from the bus/train station. There are adorable cat decorations as soon as you walk in the door and start going up the steps to the third floor. Unfortunately, they don't have cats here all the time, especially not when it's raining. The menu has a typical selection of light meals, desserts, waffles, coffee and tea. I ordered a 'red sauce bacon panini' and Americano. The 'red sauce' turned out to be salsa, with a really good spice. The presentation of the coffee was very cute.

這家基隆的咖啡館離公車站或火車站都
很近，入口的樓梯處就開始有可愛的貓裝
飾品了。但店裡並非總是有貓在，下雨天
的時候就不會有。他們的菜單有簡餐、鬆
餅、咖啡、茶。我點了紅醬培根帕尼尼，
我覺得很好吃，他們的「紅醬」有點像是
墨西哥莎莎醬，有點辣。他們咖啡的外觀
也很討喜。

Chapter3
貓超多的咖啡館
Cat cafés with lots of cats

地　　址：臺北市士林區福華路 129 號 1 樓（近芝山站）
Address ： 1F., No.129, Fuhua Rd., Shilin Dist., Taipei City
（Across from Zhishan MRT）
營業時間 Hours：11:00 － 22:00
最低消費 Minimum cost per person：NT$120
12 歲以下的孩子禁止進入。No children under 12.
電　　話 Phone：02-2835-3335

1

小貓花園 ★★★★★
Café dog & cats

Started in 1998, this has been called the world's very first cat café by major news sources. The manager modestly insisted that this is not strictly true as there were other cafés with cats before this, but it's probably safe to say that it's the oldest and most influential. This café does a good job of having plenty of cats to play with while still maintaining a high standard of cleanliness. They also make sure that the cats have their own space, having a separate closed off clear plastic room for the cats to go in so they can have a break from customers' attention. It's nicely decorated with, of course, more of a cat theme.

在一九九八年開業的這家咖啡廳被國際新聞媒體稱其為世界上第一家貓咖啡廳，但老闆謙虛地說不是這樣，畢竟在他們之前就已經有咖啡廳在店裡養貓了，但我認為這間依然稱得上是最古老、也令人最有印象的貓咖啡廳。我覺得這間咖啡廳特別棒的原因在於裡面有十幾隻貓，而環境卻仍然能維持得相當乾淨，沒有貓特有的那種味道。貓也有自己的空間，當牠們累了、不想被摸的時候可以在裡面休息。整間咖啡廳的裝潢也是以貓為主。

The café sells treats to give to the cats, and after having a treat, the cats will jump up and sit on the chairs and sometimes on customers' laps. When I went, one even

jumped on my table and drank out of my water glass! They have about 12 cats and two dogs. For years, they just had one dog, a sweet golden retriever, who was much more excited about attention than the cats are. Sadly, he recently passed away from old age. However, they now have two young yellow lab mix dogs who are also very friendly.

咖啡廳裡有賣給貓吃的零食，客人可以買來餵貓。貓一看到零食就會馬上靠過來，吃完零食，牠們偶爾會坐在客人旁邊，也可能會坐在客人身上。一隻貓還跳上桌子，喝我杯子裡的水，我覺得真的很可愛。他們養了大約十二隻貓、兩隻狗。幾年前他們有隻很貼心的黃金獵犬，牠很喜歡人們摸牠，可惜的是，最近牠因為年紀太大而過世了。不過，店裡現在多了兩隻黃色的拉布拉多米克斯，牠們也很親人。

The minimum purchase is NT$120 and there's a wide variety of coffee drinks, soft drinks and even cocktails, as well as light meals and afternoon tea options. I've had

the coffee as well as different kinds of tea, desserts and a set meal once. I'd recommend the tea over the coffee; they have many kinds made with fruit and flowers. The cheesecake is also quite good.

最低消費是 NT$120，飲料有咖啡、茶飲和調酒，食物則有簡餐和甜點。我點過他們的咖啡、甜點和套餐，但我最推薦的是茶類，他們的花果茶種類繁多，起司蛋糕也很好吃。

🐈 貓店長的故事 Cat's story

This café has about twelve beautiful cats, many of which are a bit stand-offish. The oldest cat is Qianqian, a small brown female tabby who has been there since the café opened. She spends most of her time sleeping in one of the glass rooms.

The newest resident is Qiaoqiao, a young playful cat not even a year old. One of the staff found her on a high bridge. She was only two months old at the time and had probably just been separated from her mother. She had somehow climbed up on an overpass and was crying and couldn't get down. The staff member called the fire department to rescue her and brought her to the café. At first they thought of putting her up for adoption, but she was so adorable they decided to keep her.

這家咖啡廳裡有十二隻漂亮的貓，年紀最大的叫錢錢，她是一隻小小的咖啡色虎斑貓，從咖啡館開業的時候就在了，但大部分的時間裡她都在玻璃房間裡睡覺。

最年輕的叫做橋橋，她是一隻很活潑的貓，還不到一歲。店員是在某座很高的橋上找到她的。那個時候，她還很小，才兩個月左右，剛離開媽媽身邊的她爬上了高架道，但因為不知道該怎麼下來就一直在那裡喵喵叫。店員請消防員把她救了下來，然後便把她帶到了咖啡廳裡。原本他們是打算找人來領養她的，但她實在太可愛了，於是他們便決定讓她留下來了。

 我的感想 My overall opinion

This was one of the first cat cafés I went to, and I think it's the best one to go to for a 'traditional' cat café experience. There are plenty of cats around and it's very clean. The cats are beautiful and healthy and most of them are mixed breeds. They were all adopted or rescued. The staff are friendly and happy to talk about the animals. The café has a nice atmosphere and is a good place to relax either alone or with friends.

這是我開始採訪貓咖啡店後去過的第二間店，我覺得它很有「傳統」貓咖啡廳的感覺。如果想去很多貓的咖啡廳，我認為這間是你的最佳選擇，它既有很多貓又乾淨。貓都很漂亮、很健康，大部分都是領養來的。店員很友善，很樂意講動物的故事給客人們聽。氣氛很棒，不管是一個人去還是攜伴同行都很合適。

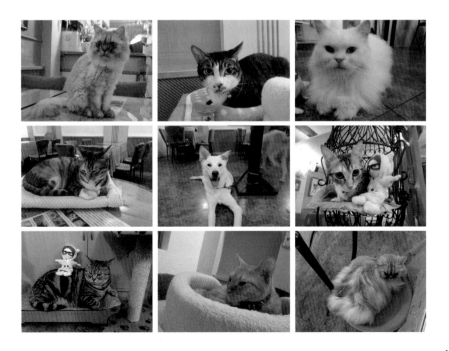

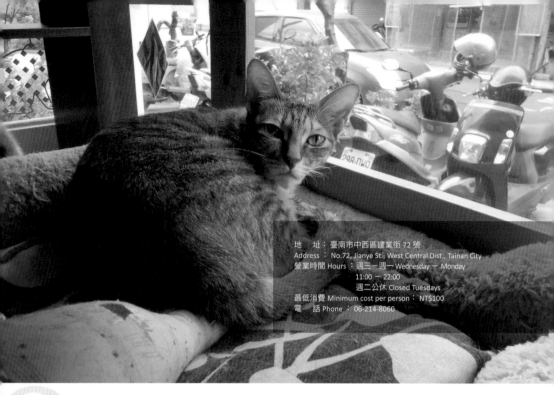

地　　址：臺南市中西區建業街 72 號
Address ： No.72, Jianye St., West Central Dist., Tainan City
營業時間 Hours ： 週三─週一 Wednesday ─ Monday
11:00 ─ 22:00
週二公休 Closed Tuesdays
最低消費 Minimum cost per person ： NT$100
電　　話 Phone ： 06-214-8060

2 AT Cats and Tea

★★★★★

This Tainan cat café has more cats than any of the others in Tainan and is very clean and well-designed. It has about twelve beautiful, friendly cats. Some cats like coming up to customers and hanging out by the tables and others prefer to stay in the cat trees near the window.

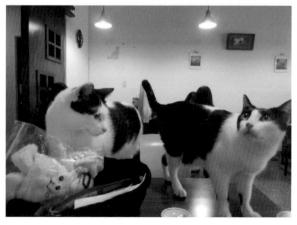

這家貓咖啡廳裡的貓是臺南最多的，店裡的環境很乾淨，設計也很不錯。店裡有大概十二隻漂亮又親人的貓，有些貓喜歡來找客人並在桌邊閒晃，而有些則喜歡躺在窗邊的貓跳台上。

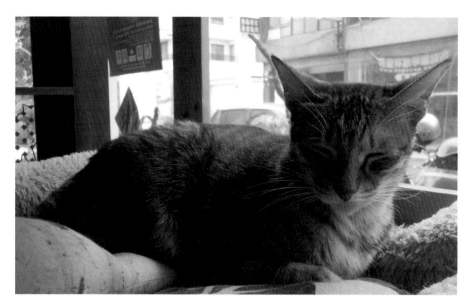

The number of cats they have at a time varies because the owner keeps a lot of cats at her home and sometimes brings different ones in, and they also often let customers adopt cats, but there are at least eleven at a time. All of the cats were either strays or abandoned by their owners, and the café works hard to give them a good home in the café or to find new owners for them. This is one of the oldest cat cafés and has been open for more than ten years.

店裡貓的數量並不固定，因為老闆家裡有很多貓，偶爾會帶一些到店裡來。雖然

他們也會讓客人領養貓，但店裡至少都會有十一隻。大部分的貓以前都是流浪貓，再不然就是被棄養的，老闆很努力地要給這些貓一個溫暖的家。這家咖啡廳滿舊了，畢竟是十幾年前就開始營業了。

The café offers the usual coffees, teas, light meals and desserts for reasonable prices. I've had the AT Cats & Tea coffee（NT$110）and pancakes filled with green tea cream and red beans（NT$80）. All the cups have lids on them to keep the cats out. The cold drinks have a wooden lid with a hole in it that's just right for a straw!

這家的咖啡、茶 都 很 好 喝，菜 單 上 還 有 簡餐、點心，價格也 都 很 合 理。我 點 過 AT Cats & Tea 招牌咖啡（NT$110） 和抹茶紅豆薄煎餅

（NT$80）。杯子有加蓋，這樣貓才不會偷喝。冷飲的木製蓋子都有一個洞可以插吸管。

🐈 貓店長的故事 Cat's story

All of the cats have been adopted so they each have their own rescue story. One of the sweetest cats is a little calico known as Xiaohua. A university student found her as a kitten with a seriously injured eye. He didn't know what to do for her himself so he brought her in to the café. The boss took her to the vet and she recovered but never got back the sight in one eye.

每隻被領養的貓都有屬於自己的故事。

其中一隻很可愛、很親人的花斑貓叫做小花，她還是小貓時被一名大學生發現了，當時她的左眼受了很嚴重的傷。學生不知道該怎麼辦，便將她帶來了咖啡館。老闆將她帶去接受醫生的治療，在老闆細心的照顧下，她慢慢恢復了，可惜她的左眼仍然看不見。

They were thinking of putting her up for adoption but decided to keep her as her health is still delicate. She happily approaches people and jumps on their laps and tables. She also loves playing with toys.

老闆原先想找人領養她，但她的身體有點虛弱，於是便將她留了下來。她很喜歡客人，會跳到客人身上或是桌上，她也很喜歡玩玩具。

They also have a small family of cats, a grey female and her two now grown children. They didn't realize the cat was pregnant when they found her, but she gave birth to four kittens. The other two were adopted by customers.

店裡還有個貓家庭，是一隻灰色的母貓和她的兩個孩子。當老闆見到她的時候並不知道她懷孕了，後來她生下了四隻小貓，兩隻還在店裡，另外兩隻則被客人領養走了。

 我的感想 My overall opinion

This café has a nice atmosphere and adorable, friendly cats. They also have Wi-Fi, so it would be a good place to work or study. They also do a lot to help stray, injured or abandoned cats, giving them a temporary home and finding people to adopt them.

我很推薦這間店，氣氛很好，貓很可愛也很親人。店裡提供 Wi-Fi，不管要工作還是讀書都很合適。他們幫助了許多流浪的、受傷的、被棄養的貓，給了牠們一個暫時的家，並找人領養牠們。

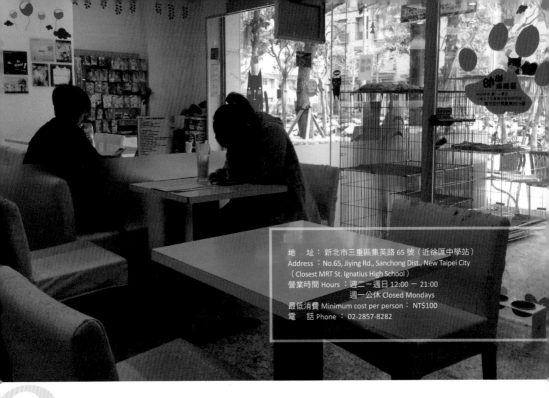

地　　址：新北市三重區集英路 65 號（近徐匯中學站）
Address ：No.65, Jiying Rd., Sanchong Dist., New Taipei City
（Closest MRT St. Ignatius High School）
營業時間 Hours：週二一週日 12:00 － 21:00
週一公休 Closed Mondays
最低消費 Minimum cost per person： NT$100
電　　話 Phone： 02-2857-8282

3 野喵中途咖啡
Stray Cats Café ★★★☆☆

This isn't just a cat café; it's also kitten café! It's quite out of the way, near the end of the Luzhou line and more than a kilometer's walk from the station, but I wasn't disappointed with my first visit.

They usually have 12-15 cats at a time, often kittens. Most of the cats are available for adoption, so there are different cats

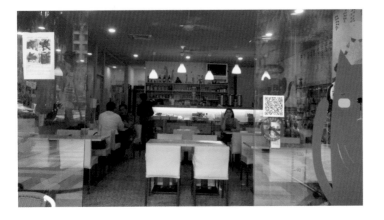

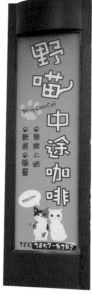

處都是活潑又親人的貓咪。

In the no-cats section, they sell cat-themed clothes, bags and jewelry as well as pet products. All of the cats and kittens were strays and they try to find homes for them, so going to this café is supporting a good cause.

他們也賣以貓為主題的東西，包括：衣服、包包、首飾和寵物用品。他們的貓咪都是流浪貓，店裡的小貓也開放領養。

every time. Even with that many cats, it's very clean and doesn't smell at all. There are two separate seating areas, one in the cats' room and one outside of it, though most people sit in the cats' room. Playful, friendly cats romp all over the place.

這不只是間貓咖啡館，它更是一間小貓咖啡館！搭蘆洲線，從車站出來還要走上超過一公里的路，我覺得有一點遠，但我第一次造訪它的時候，這裡真的沒有讓我失望。

平常店裡會有十二到十五隻貓，幾乎都是小貓！大部分的小貓都開放領養，所以每次去都會有不一樣的貓。雖然店裡貓口眾多，但還是很乾淨，幾乎沒有臭味。這裡有有貓或是沒有貓的兩個區域可以選擇，但是大家都選擇坐在有貓的區域，到

The first time I went, I ordered a Mexican Spice Chicken with rice and black coffee（NT$200 for the meal and NT$90 for the coffee）. There was nothing "Mexican" about the chicken, though it wasn't bad. I later went with a friend and we each got a different flavor waffle, chocolate and mango （NT$180）. Those tasted good and had ice cream on them. Another time, I got a chocolate banana sundae （NT$140）, which looks impressive, but they put ice cubes under it for some reason, so some of the ice cream gets wasted unless you want to drink watery melted ice cream.

我初次到訪時點了墨西哥辣味雞腿飯（NT$200）跟黑咖啡（NT$90），雖然不是正統的墨西哥的風味，但也不錯。我另一次跟朋友去的時候，我們兩個點

了不一樣的鬆餅，一個點了巧克力，另一個點了芒果，但都是NT$180，也都很好吃，上面還有冰淇淋。我還點過巧克力香蕉聖代（NT$140），看起來很好吃，可惜他們會把冰塊放在下面，底下的冰淇淋會跟冰塊融化的水混在一起變得不好吃。

🐈 貓店長的故事 Cat's story

The 'cat boss', and the only cat who is absolutely not up for adoption is Kusi, a friendly black and white cat. He comes to greet all the customers by rubbing on them and jumping on their table. Kusi was found by a young man who wanted to take him in, but his mother didn't like cats. The young man tried to hide the cat from his mother, but was unsuccessful, so he took him to the café. The most recent time I went, Kusi was wearing a minion costume.

It looked adorable, though I always feel a bit sorry for cats in costumes.

本店的「貓店長」，也就是你每次去都會看到，也不會被領養走的貓 Kusi，他是一隻很親人的黑白貓。當他看到客人時總會到他們桌邊，彷彿是在跟客人打招呼。原本是另一個男生在路邊發現了 Kusi，他是想養 Kusi 的，但他的媽媽不喜歡貓，所以他只好偷偷養，可惜被媽媽發現了，所以他只好把 Kusi 帶來咖啡館了。我上次看到 Kusi 穿著小小兵的衣服，看起來真的好可愛，不過我覺得讓貓穿衣服有點可憐。

There's another very sweet orange cat who is outside most of the time. Because they say clearly on the door and on the menu that they're open every day, including Mondays, I went on a Monday. They do say on Facebook that they're closed on Mondays, but they really need to update that on their printed information. Only that cat was there and he seemed lonely and happy to see me. I knelt down to

pet him and he jumped on my lap. He curled up and fell asleep, so I sat outside there for some time, just petting him. He's allowed inside the café sometimes, but not in the cat room. They say he's more of a stray cat. I think he's even nicer than some of the cats in the cat room though.

他們還有一隻很親人的橘貓，平常都在外面。他們的菜單和外面的單子都說他們每天都有開，但我沒注意到他們的粉絲團上有說週一公休，所以我禮拜一去的時候就撲空了。我很失望，但他們的貓在外面，一副很寂寞的樣子，他看到我似乎很開心，撲到我身上就睡著了。我便在那裡坐了一下下，摸摸他。雖然他能進咖啡館，但他們說他屬於流浪貓，所以不能進去貓咪的房間，不過我覺得他比貓咪房間裡的某些貓還親人。

我的感想 My overall opinion

I was initially impressed by this place because of all the cute cats. It's fun to play with them, and they really have helped a lot of stray cats get good homes. I'd recommend it just for the sake of the cats. However, the boss and the staff have a bad attitude; perhaps because the place is so popular now, they think they don't have to talk to customers. There were three people working and only two other customers, but they still didn't want to bother answering my questions, so that really changed my opinion of them.

我對這裡的第一印象不錯，因為這裡有很多可愛的貓，跟牠們玩很有趣，這家咖啡廳也確實幫助不少貓咪找到新的家，我會推薦絕對是因為貓的關係。但我覺得店員跟老闆的態度都比較冷漠，似乎店很忙所以不太有時間跟客人講話，我去的時候他們有三個人在工作，店裡只有兩個客人，但他們還是不願意跟我多說話，這讓我有點遺憾。

地　　址：臺中市北區南京東路二段 13 號
Address ： No.13, Sec. 2, Nanjing E. Rd., North Dist., Taichung City
營業時間 Hours ：週三一週一 Wednesday — Monday 15:00 — 23:00
週二公休 Closed Tuesdays
營業時間不一定，建議先打電話，FB 留言：recommend
calling or checking Facebook as hours are sometimes irregular
最低消費 Minimum cost per person ： NT$120
電　　話 Phone ： 04-2360-1647

六號貓洞
Cat Lair 6　★★★★★

I think this is the best cat café in Taichung and one of the best in Taiwan, especially on a nice day. The front of the café is completely open and the cats can lounge in the courtyard or come inside as they choose. There is seating outside, at the bar or on vintage chairs and couches inside. The decorations are the most original I've seen.

Everything is the owner's design. She says she just chose all the things that she likes, and many of the paintings are her own artwork.

　　我覺得這家貓咖啡廳是臺中最棒的，甚至在全臺灣都算是頂尖的貓咖啡廳之一，尤其是在天氣好的時候。外面有一個很可愛的天井，貓會在那裡跑來跑去，人可以坐在外面，可以坐在吧檯，也可以坐在他們古老的沙發上。

他們的裝潢、家具都很特別，全是老闆
親手設計的。她說她都選自己最喜歡的東
西，還有不少張圖都是她自己畫的。

The number of cats at the café at a time
isn't definite because the owner keeps

some at home. She has eleven but there are
usually five or six at the café. They are all
very friendly and happy to be petted.

　　咖啡廳裡貓的數量並不固定，雖然老闆
養了十一隻貓，但總會留幾隻在家裡，通
常只會帶五、六隻來咖啡廳。這些貓都很
親人，喜歡人們摸牠們。

They serve coffee, tea, frappuccinos
and freshly baked bread. I've had an Oreo
frappuccino （NT$170）, which was
very good. I've also had the garlic bread
（NT$160）. All the bread comes from
a local bakery and they have different
specialties each day.

　　他們有咖啡、茶、冰沙和現烤麵包。他
們的 OREO 冰沙（NT$170）很好喝，我
還吃過他們的蒜香法式麵包（NT$160）。
所有的麵包都是來自附近的麵包坊，每天
都有不一樣的麵包。

🐈 貓店長的故事 Cat's story

All of the cats were given away or abandoned by their owners.

One very sweet grey tabby cat, Bujiu, ate rat poison. Her owner took her to the vet and abandoned her there, not wanting to pay the bill. Bujiu had to stay in the animal hospital for a long time but she eventually recovered. The café owner paid the bill, over NT$10,000 and adopted Bujiu.

Now Bujiu has a very happy life at the café. She enjoys being petted and cuddling with her best friend Reborn.

店裡所有的貓都是被以前的主人所棄養的。

其中一隻可愛的灰色虎斑貓叫做卜啾，她之前誤吃了老鼠藥，雖然之前的主人帶她去看獸醫，但卻因為醫療費用太高就棄養她了。卜啾在動物醫院待了很久，但她總算是好了起來。後來老闆付清了超過一萬元的醫療費用，並領養了她。

卜啾在咖啡廳裡的生活非常開心，她喜歡客人們摸她，也很喜歡跟她最好的朋友里包恩在一起。

Reborn is a large orange tabby who loves attention. The café owner took him in temporarily at first, thinking of finding someone else to adopt him. The longer she kept him, the more attached she got to him, though, so she decided to keep him. He loves Bujiu and they can often be seen together.

里包恩是一隻很大的橘貓，很喜歡人。老闆本來只是暫時收留他，還打算找別人領養他，但相處的日子越久，老闆就越喜歡他，所以老闆便決定留下他了。他很愛卜啾，他們經常膩在一起。

我的感想 My overall opinion

I love the atmosphere of this café—the name 'Cat Lair'fits it very well. With the tree branches around the doorway, it feels like a secret hideaway in a forest even though it's in the middle of the city. The cats are so friendly and happy, and the owner is nice to talk to and very obviously enjoys her job. It's a great place to relax; one could easily spend a few hours here and hardly notice the passing time.

我非常喜歡這裡的環境。我覺得名字很貼切，門口有枝很大的樹枝，讓這裡感覺起來像是森林裡的小洞。貓都很開心、很放鬆，老闆也很熱情。顯然地，老闆十分熱愛她的工作。這是一個放鬆的好地方，可以讓人在這裡一坐就是好幾個小時。

地　　址：臺中市北區大德街 131 號
Address ： No.131, Dade St., North Dist., Taichung City
營業時間 Hours ：週二～週日 Tuesday ─ Sunday 10:00 ─ 21:00
週一公休 Closed Monday
最低消費 Minimum cost per person：NT$100
電　　話 Phone ： 04-2202-5268

貓爪子咖啡
Cat's Claw Brunch & Café' ★★★★☆

This Taichung cat café has four beautiful cats, lots of cute decorations, and they specialize in brunch.

All the cats were adopted, and they are all lovely and well-cared for. One striking blue-eyed cat looks like a cross between a Siamese and a grey tabby. On the second floor in a glass room by the bathroom is a playful Bengal cat. A fat long-haired black cat spends most of his time curled up asleep and the star, Ah-Long, is usually outside.

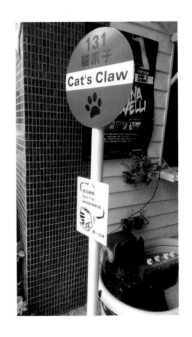

這間位於臺中的貓咖啡廳有著四隻很漂亮的貓，還有許多可愛的裝潢，而早午餐是他們的招牌。

店裡的貓都是領養來的，都很可愛、很健康。一隻有著藍色眼睛的貓似乎是暹羅

貓和虎斑貓的混血，二樓廁所前的玻璃房間裡則是有隻好動的孟加拉貓，而胖胖的長毛黑貓經常睡在客人旁邊，貓店長阿龍則是經常在外面。

Cute cat themed decorations are all around. Even the stairs have little black cats painted on the baseboard. There's also a bookshelf filled with cat-themed books for customers to read while they eat.

their brunch specialties, a mushroom omelet set that came with milk tea. I'd highly recommend it. The second time was later in

店裡到處都是可愛的貓的裝飾品，樓梯上還畫有小黑貓的圖片，也有跟貓相關的書籍供客人閱覽。

The first time I went, I had to try one of

the afternoon and I just had the 'Cat's Claw Specialty' coffee. It had a good strong flavor and was served with milk.

我第一次來時是吃早午餐，一個香菇蛋餅套餐加奶茶，這樣 NT$220，我覺得很棒。第二次來的時候是下午了，我只點了他們的招牌咖啡（NT$120），搭配牛奶的味道也很棒。

貓店長的故事 Cat's story

The star of this cat café, Ah-Long, has his own Facebook fan page and nearly 30,000 fans. He spends most of his time by a table outside the café, where he gives customers a friendly welcome. The spiked collar around his neck makes him look tough, but he's happy to be petted.

貓店長阿龍有自己的 Facebook 粉絲團，有近三萬名粉絲。大部分的時間他都躺在外面的桌子旁跟客人打招呼。雖然他的項圈讓他看起來有點兇，但其實他很享受人們摸他。

Ah-Long has been in the café for about two years now; he was seven years old when he was adopted, but as soon as he arrived in the café, he established his place. He was raised far up in the mountains and was a bit of a wild cat, often wandering far from his home. His owner couldn't keep him anymore and gave him to the café owner. Now Ah-Long is content to stay at the café. He gets along well with the other café cats, but chases away any stray cats and has even been known to chase dogs.

阿龍住在這裡已經兩年了，他在七歲的時候被老闆領養，所以他到這裡沒多久就建立起了自己的地位。由於在山裡長大，所以阿龍就像個野孩子，常常離家四處遊蕩。他原先的主人沒辦法繼續養他，便把他送給了老闆。阿龍相當滿意在這裡的生活，也跟其他貓處得不錯，但他會追其他流浪貓，有時候甚至還會追著狗跑。

 我的感想 My overall opinion

This place has a bright, welcoming atmosphere, and any cat-lover is sure to want to come in when they see Ah-Long on the porch. The food is delicious, and it's also a nice place to stop for a quiet cup of coffee, to sit and read or just play with the cats.

這家咖啡廳的環境很好，光線也很明亮。看到阿龍在店門口，每個愛貓的人都一定會想進去。食物很好吃，就算只想喝咖啡、看書、跟貓玩也是個很好的去處。

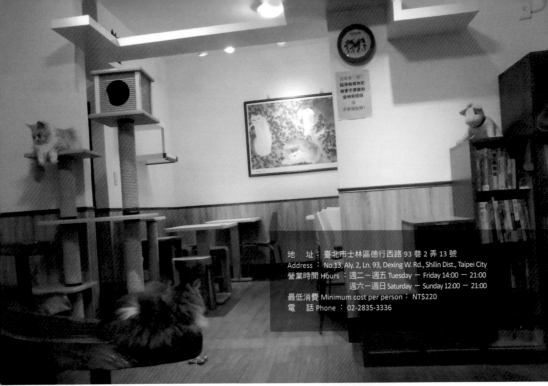

地　　址：臺北市士林區德行西路 93 巷 2 弄 13 號
Address：No.13, Aly. 2, Ln. 93, Dexing W. Rd., Shilin Dist., Taipei City
營業時間 Hours：週二─週五 Tuesday ─ Friday 14:00 ─ 21:00
　　　　　　　 週六─週日 Saturday ─ Sunday 12:00 ─ 21:00
最低消費 Minimum cost per person： NT$220
電　話 Phone： 02-2835-3336

6 元氣貓主題咖啡
Genki Cats ★★★★★

This was one of the first cat cafés I went to, and it's home to 22 cats, mostly purebreds, all raised by the owners. The café is more than ten years old, but it has moved several times, all in the Tianmu area.

When I first visited about three years ago, they had a separate tea/shaved ice shop where people could buy tickets to go into the apartment across the street where the cats were. Their new location is only about five minutes walk from the old one, just across from Zhishan MRT Exit 2. In their new location, they sell more extensive meals served in the same room with the cats.

這是我最起先去的幾家貓咖啡廳之一，他們有二十二隻貓，大部分是純種的，全部都是由老闆一手帶大的。這家咖啡廳從十幾年前就開始營業，但輾轉在天母搬了幾次家。

我第一次來是在三年前，他們分開了用餐區跟貓區，以前他們只賣茶飲跟剉冰，貓區則是在對面的房子。現在他們離以前的店址很近，就在芝山捷運站二號出口對面。現在的菜單有了比較多的選擇，用餐區跟貓區也合在一起了。

Before entering the main room, customers need to take off their shoes and wash their hands. The large, bright room is filled with beautiful fluffy cats relaxing in cat trees, on the floor and on the tables and chairs. The cats are mostly Maine Coons. Maine Coons are huge, gentle, long-haired cats who usually have a calm personality.

There's also an Abyssinian, a couple of Scottish folds and Persians, and a few Maine Coon/Persian mixes. They are all very sweet and happy to be petted. Some are more outgoing than others; I had one on my table and another on the chair next to me.

進咖啡廳之前，客人得要先脫鞋、洗手。在一個很大、很明亮的空間裡，許多漂亮的貓趴在貓樹上、躺在地上、桌子上或椅子上。店裡大部分的貓是緬因貓。緬因貓是一種很大但又很溫和的貓，大部分的性格都相當沉穩。

他們還有阿比西尼亞貓、蘇格蘭摺耳貓、波斯貓，還有幾隻是波斯貓和緬因貓混種的。這些貓都很親人，喜歡人們摸牠們。其中有些比較外向，有隻貓坐在我的桌子上，還有一隻貓則是坐在我旁邊的椅子上。

沒有臭味。貓都相處得很好，這個地方有種讓人放鬆的氛圍。

貓店長的故事 Cat's story

The oldest cat in the café is Pussy, a queenly Persian who was born in 2003. She has been in the café since it started and many of her descendants are there now.

The owner introduced me to several of the cats, and told me how they are related. Pussy had some kittens with a Maine Coon （this was an accident as they try to spay and neuter all their cats before there's a chance of something like that happening）, and now they're grown and also live in the café.

The minimum cost to enter is NT$220 and most of the drinks are close to that price. They have the usual coffee and tea drinks. I'd recommend ordering a set meal as it's a much better bargain. I had the udon noodles set （udon with a choice of meat, side dishes, a dessert and a drink） for NT$350. The drink I chose was an iced caramel macchiato （NT$20 more）.

　　每個人的最低消費是 NT$220，店裡大部分的飲品都在那個價位。他們有普通的咖啡和茶飲。我會推薦套餐是因為比較划算，像我點烏龍麵套餐（烏龍麵，可選肉、小菜、甜點及飲料）只要 NT$350，我選冰的焦糖瑪琪朵要加 NT$20。

This is a nice place to go if you want to be surrounded by happy cats. Even though there are so many of them, the café is very clean and doesn't smell. The cats get along well and the place has a relaxing atmosphere.

　　如果你想被快樂的貓咪們簇擁，這裡絕對是一個好去處。雖然這裡有很多貓，但咖啡廳裡卻還是很乾淨，也

店裡最年長的貓叫做 Pussy，她是一隻在二○○三年出生的優雅波斯貓，從咖啡廳開業的時候她就已經住在咖啡館裡了，現在有不少她的子孫還在店裡。

老闆向我介紹了其中幾隻貓，並跟我說牠們都是親戚。Pussy 跟其中一隻緬因貓生了小貓（這是意外，他們後來就為貓咪節育了），這些小貓長大後也都住在咖啡廳裡。

Zhubi is the largest cat, a bear-like black and grey Maine Coon who is happy to get attention. He's also one of the youngest, just born in 2014.

朱比是其中最大、看起來也最像熊的黑灰色緬因貓，他很喜歡人，不過由於他是二○一四年才出生的，所以他是店裡年紀最小的一隻。

 我的感想 My overall opinion

This is one of my favorite cat cafés because it has so many cats and because they're all so content. It's difficult to keep a large number of cats in one place and make sure they're clean and happy but this café has succeeded at this. I enjoy the quiet atmosphere and being able to play with and watch the cats interact with each other.

這是我最喜歡的貓咖啡廳之一，不只是因為貓很多，更因為牠們都很快樂。很難得看到這麼多貓被養在一起卻又保持著環境的整潔，但這間咖啡廳真的做得很好。我喜歡安靜的環境、跟貓玩，也喜歡看貓玩在一塊。

地　　址：高雄市左營區光興街 49 號
Address ： No.49, Guangxing St., Zuoying Dist., Kaohsiung City
營業時間 Hours ：平日 Weekdays 12:00 － 21:00
　　　　　　　　週末 Weekends 11:00 － 22:00
　　　　　　　　週一公休 Closed Mondays
最低消費 Minimum cost per person ： NT$100
電　　話 Phone ： 07-556-8728

日光貓
Sunbeam Cat ★★★★☆

This is one of just a few cat cafés in Kaohsiung. With its cute decorations, reasonable prices and eight adorable cats, it's definitely worth a visit. The cats enjoy hanging out in the front window, enticing customers to come in.

這家是高雄少數幾家貓咖啡廳之一，他們的裝潢很可愛，東西物美價廉，加上有八隻漂亮的貓咪，絕對值得你走上一趟。店裡的貓很喜歡坐在前方的窗戶旁，彷彿是在引誘著往來的行人走進咖啡廳裡。

Other beautiful cats relax in other places around the café. They're not at all afraid

of people, but not particularly interested in them either. The walls are decorated with cat puzzles.

其他漂亮的貓咪都在咖啡廳裡的各個角落，並不是每隻貓都怕人，只是牠們對人並不是很感興趣。牆上還有貓咪拼圖作為裝飾。

The menu has a variety of set meals including sandwiches, pasta and waffles. I had an original waffle and an iced Americano for NT$165.

The waffle was delicious and they have lots of flavors to try, although some of them have to be special-ordered the day before, like the caramel and cream cheese that I wanted. Another time I went, I had a

cranberry vinegar （NT$100）, refreshing for a summer day.

菜單上有很多套餐，包括：三明治、義大利麵、鬆餅等。我點了原味鬆餅加上冰美式咖啡，這樣只要 NT$165。

鬆餅很好吃，他們有很多種口味可以選，但有些口味得要前一天打電話預定才有。我第二次來的時候點了蔓越莓果醋（NT$100），夏天喝真的非常過癮。

貓店長的故事 Cat's story

This café is home to eight cats. The friendliest, and also the youngest, is Qiaoqiao. He's a beautiful fluffy white cat who is happy to have anyone pet him and

doesn't even mind being picked up. The café owner adopted him from someone who couldn't keep him anymore.

All of the cats at the café were adopted, either brought in by customers or found by people who work at the café.

咖啡館是八隻貓的家，其中最親人的是喬喬，她也是裡面最親人的一隻。她是一隻很漂亮、毛很蓬鬆的白貓，她很喜歡人們摸她，她也不介意人們抱她。因為她以前的主人沒辦法繼續養她，所以老闆便領養了她。

他們所有的貓都是領養來的，要麼是客人帶來的，要麼就是店員在外頭發現的。

 我的感想 My overall opinion

As soon as I saw the cats in the window, I had a good impression of this place. It's laid out nicely for the cats and while the furnishings and decorations are simple, it's a fun place to sit and watch the cats. It's not quite as clean as some, though not as bad as some others that have this many cats. If you want to go to the café in Kaohsiong with the most cats, this is the place to go.

當我看到貓咪坐在窗邊時,我就對這家咖啡廳有了很好的印象。他們對貓很好,店裡的家具與裝潢都走極簡風,這裡是個坐著看貓的好所在。他們也許不像某些貓咖啡廳那樣乾淨,但比起某些店裡有著許多貓的咖啡廳,他們算維持得不錯的了。如果你想去高雄有著最多貓的貓咖啡廳,我會推薦這裡。

極簡咖啡館 Minimal 的貓店長

8

特選 / 更多貓咪
More cafés with lots of cats

These are more cafes that have lots of cats. They're not among my favorites, but may be worth checking out if you're in the neighborhood.

這些是更多有很多貓的咖啡. 不是我最喜歡的, 但是如果在附近可能值得看一下.

極簡

地　　址：臺北市大安區泰順街 2 巷 42 號（近師大夜市）
Address ： No.42, Ln. 2, Taishun St., Da'an Dist., Taipei City
　　　　　（Near Shida Night Market）
營業時間 Hours ：12:00 － 23:00
最低消費 Minimum cost per person：NT$120
電　　話 Phone ：02-2362-9734

極簡咖啡館
Minimal

★★☆☆☆

This popular cat café is near Shida Night Market, and with at least 20 cats, it's hard to find another café that can beat it in terms of numbers. On a nice day, there are cats on the benches outside or curled up on the seats of parked scooters. Inside, they sit on the counters, over the dishes, in chairs. on tables, everywhere.

But while they may look cute, there's a problem with having so many cats– they stink. Walking into this café is like walking into an animal shelter. There's an

這間師大的貓咖啡館很有名，店裡有二十幾隻貓，可能是臺北有著最多貓咪的咖啡館。天氣好時，有些貓會坐在外面，可能是在機車上或是長椅上，店裡的貓則會坐在櫃臺、椅子或桌子上，到處都是。

overwhelming odor of cat urine. Probably the carpet and the cushioned chairs don't help. As it's always busy, I assume most people don't mind it.

It think it's good that they take in a lot of stray cats, but with that smell, I don't want to eat or drink anything there.

牠們看起來很可愛，但有個問題 ——味道很重。味道聞起有點像是流浪動物之家，有很重的貓尿味，也許是因為他們有地毯又有軟椅很難清理，而大部分的人們也不像我一樣比較敏感。

我覺得幫助流浪動物是件好事，但是聞到這個味道實在讓我提不起食欲。

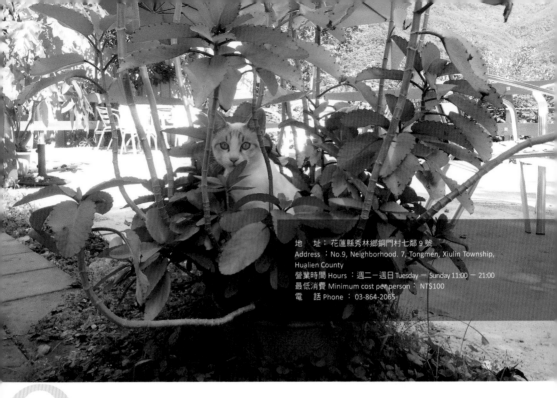

地　　址：花蓮縣秀林鄉銅門村七鄰 9 號
Address ：No.9, Neighborhood. 7, Tongmen, Xiulin Township,
Hualien County
營業時間 Hours ：週二—週日 Tuesday — Sunday 11:00 — 21:00
最低消費 Minimum cost per person：NT$100
電　　話 Phone： 03-864-2065

82

貓尾巴咖啡
Cat's Tail Café ★★★★★

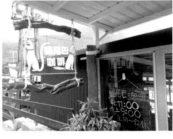

I haven't actually been to this café but I still wanted to share it for any readers living in eastern Taiwan. The owner was kind enough to send me some pictures and it sounds great. It's outside of the city with a beautiful view of the mountains, and the cats are in and out. The cats are friendly and healthy and get along well with each other. They serve a variety of coffee and tea drinks in cute mugs and have full meal and dessert options. It's about 15 kilometers from

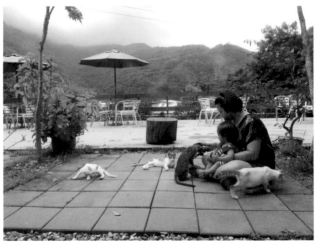

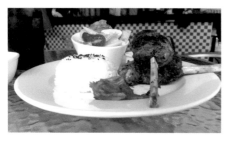

Hualien train station and while there are bus services that go there, they aren't frequent.

　雖然我沒去過這間，但我還是想分享給東部的讀者們知道。老闆人很好，寄了一些照片給我，看起來真的很棒。它在鄉

下，有著美麗的山水風景。貓可以在外面玩，都很可愛、很健康，彼此也處得不錯。菜單上有咖啡、茶飲、套餐和甜點。他們的馬克杯很可愛。這間咖啡館離花蓮火車站大概十五公里，有公車可以搭，只是班次有點少。

地　　址：新北市永和區博愛街 5 號
Address：No.5, Bo'ai St., Yonghe Dist., New Taipei City
營業時間 Hours：週三－週四 Wednesday － Thursday
　　　　　　　　14:00 － 21:00
　　　　　　　週五－週日 Friday － Sunday 12:00 － 22:00
最低消費 Minimum cost per person：NT$150
電　　話 Phone：0919-196880

貓藝家
Cat. Art. Home ★★★☆☆

The outside of this café looks inviting. Customers remove their shoes at the door and have to have their hands sprayed with disinfectant on entering. This would lead one to believe that the café is a clean place; however, it has a rather strong cat urine smell. All the tables are low, and people sit on cushions on the floor with the cats. They have 10 or so cats that are friendly and healthy looking. Customers can also bring in their own cats. I would recommend this more highly if it weren't for the smell.

　　咖啡廳的外觀非常誘人，客人進去之前得先脫鞋、洗手，所以照道理應該是很乾淨，但裡頭卻有濃厚的貓尿味。桌子很低，客人們是坐在地板的墊子上。他們有十幾隻貓，看起來都很健康，客人也可以帶自己的貓來。如果沒有那股味道的話，我會更推薦這家咖啡廳的。

地　　址：新北市淡水區公明街 61 號（近淡水站）
Address ： No.61, Gongming St., Tamsui Dist., New Taipei City
　　　　　（Near Danshui MRT）
營業時間 Hours ：週一－週五 Monday － Friday 12:00
somewhere between 20 － 22:00 （時間比較彈性）
週六 Saturday 9:00 ～ , Sun. 10:00 ～公休時間不定，
請上 Facebook 查詢或打電話詢問
最低消費 Minimum cost per person ： NT$100
電　　話 Phone ： 02-2620-0145

貓雨咖啡廳
Cat Rain ★★★☆☆

This Danshui café has more than 20 friendly cats and three dogs and is still relatively clean.

They sell entrance tickets for NT$100, but that amount will be applied to your meal. In front of the store, they have a stand selling fried chicken, French fries and other fried things, and people can just get that to go without buying a ticket.

這家淡水的貓咖啡廳有二十幾隻可愛的貓和三隻狗，裡面還算滿乾淨的。

客人得要先花 NT$100 買門票入場，但可以折抵消

費。店前面有人在賣炸雞、薯條之類的食物，單純買這些食物沒有入場的話就不用買票。

The menu has many set meals to choose from, most for NT$290. I recommend the fried chicken, French fries, fruit and drink set.

The cats are all over the place, upstairs and downstairs. All of the cats and dogs were strays that the café owner has taken in. I used to like this place more before the owner started putting clothes on the cats. The last time I went, they all had costumes on and looked very unhappy about it.

菜單上有許多種套餐，大部分都是NT$290。我吃過他們炸雞、薯條、水果、飲料的套餐。

樓上樓下都有貓，全部的貓和狗以前都是流落街頭然後被老闆領養的。我以前很喜歡這間店，但我去的時候，貓都穿著衣服，看起來不是很開心。

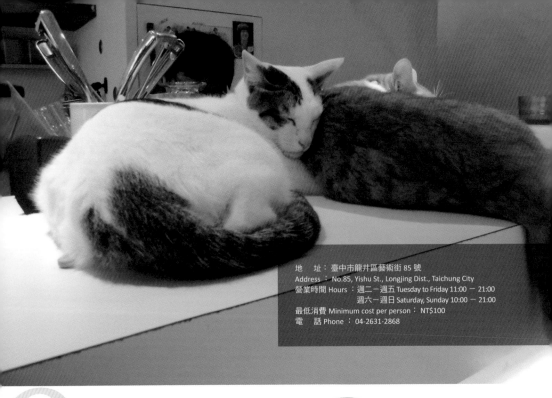

地　　址：臺中市龍井區藝術街 85 號
Address ：No.85, Yishu St., Longjing Dist., Taichung City
營業時間 Hours：週二－週五 Tuesday to Friday 11:00 － 21:00
　　　　　　　週六－週日 Saturday, Sunday 10:00 － 21:00
最低消費 Minimum cost per person：NT$100
電　　話 Phone ：04-2631-2868

8
5
背包貓
Rucksack Cat ★★★★☆

This Taichung cat café has about ten friendly cats. It's clean and bright and the cats have lots of room to climb and play. It's quite busy and seems to be popular with families and groups of friends. They offer the usual coffees, teas, desserts and light meal options. I had an apple tart（NT$70）and an Americano（NT$80）. This is a nice café and I'm impressed with how clean they keep it with the number of cats. It's not quite as unique as some of my favorites, but it's worth a visit if you're in the area.

這間臺中的貓咖啡廳有大概十隻親人的貓，環境很乾淨、光線很明亮，貓有很多空間可以玩耍。客人很多，這裡似乎

是個家庭或朋友聚餐的熱門場所。他們
提供一般的咖啡、茶、甜點與輕食。我
點過他們的蘋果塔（NT$70）和美式咖啡
（NT$80）。

　我覺得這間還算不錯，雖然有很多貓但
還是維持得很乾淨。儘管特色點還在經營
中，但如果人就在附近的話還是值得走一
趟的。

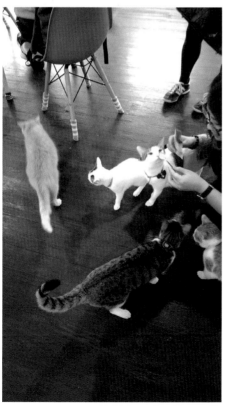

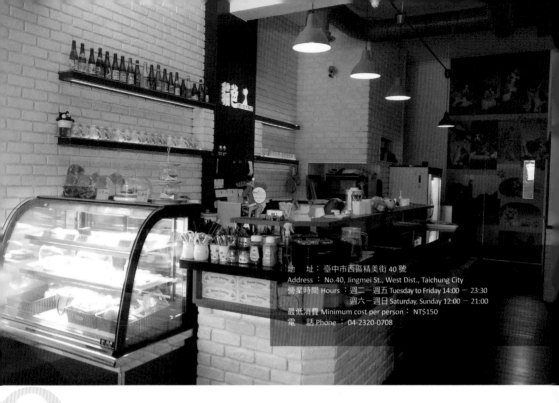

地　　址：臺中市西區精美街 40 號
Address ：No.40, Jingmei St., West Dist., Taichung City
營業時間 Hours ：週二－週五 Tuesday to Friday 14:00 － 23:30
　　　　　　　週六－週日 Saturday, Sunday 12:00 － 21:00
最低消費 Minimum cost per person： NT$150
電　　話 Phone ： 04-2320-0708

貓爸
Cat Bar ★★★☆☆

The cats in this Taichung café are Munchkin/English shorthair mixes, and they look adorable. Some are friendly and some are a bit skittish. Also, unfortunately some of them don't use the litterbox. I smelled a strong odor when I went in.

I ordered beer in a bottle （NT$150＋10% service charge）, since that seemed like a clean choice. They have a good variety of beers available. They also have coffee, tea and set meals. It's nice to see the cats there, but with the smell, I didn't have much appetite for food or drink.

這家咖啡廳裡的貓是英國短毛貓的混種，牠們短短的腿非常可愛。有些貓喜歡人，有些就有點怕生。可是有些貓不愛用貓砂盆，所以我一進去就聞到一股很重的貓尿味。

我點了一瓶啤酒（NT$150＋10% 服務費），因為這似乎是最單純的選擇了。他們有很多種啤酒、咖啡、茶和套餐，貓也很可愛，但是我對於用餐環境的異味比較挑剔。

Chapter4

更多有貓的好地方
Other place with cats

地　　址：臺北市大安區金山南路二段 134 號
Address：No.134, Sec. 2, Jinshan S. Rd., Da'an Dist., Taipei City
營業時間 Hours：20:00 － 4:00
最低消費 Minimum cost per person：NT$140
電　話 Phone：02-3393-3000

貓酒吧
Old' 98

★★★★★

This is a late night lounge bar near Guting MRT, and it has an adorable cat named Moet. With people drinking and throwing darts, a cat might not be very likely to come out, but this one seems to enjoy the atmosphere. She walked around visiting all the customers and was fascinated with the darts game. She also likes climbing on cases of beer.

這是古亭附近一間比較新的酒吧，他們有隻叫做 Moet 的貓。人們在裡面喝酒、玩射飛鏢，貓應該是不會喜歡這種環境，但 Moet 卻似乎很享受這

本章圖片感謝貓酒吧 Old'98 獨家提供

172

they made me a cocktail with that along with orange, lime, grapefruit, cachaça, and possibly some other ingredients. That was also very good. The cocktails are a bit expensive （NT$300-350） but they're definitely high quality and a lot of skill goes into making them.

種氣氛。她穿梭在客人之間，對射飛鏢非常感興趣，也很喜歡在啤酒箱爬上爬下。

Early in the evening, this bar is rather quiet and would be a nice place to relax with friends. Their specialty is all kinds of cocktails. Any kind of alcohol you can think of, they probably have it, and their skilled bartenders will make it into some kind of concoction just for you.

剛入夜的時間裡，這裡比較安靜，很適合跟朋友聊天、放鬆。這家店的招牌是各式各樣的調酒，只要你想得到，這裡都有，想要喝什麼，經驗老道的酒保全部都會調。

They don't have a menu, though they do have a blackboard with a few special drinks listed. They prefer to make just what the customer asks for. I've had a whisky sour and a Manhattan, which were very good. I went early one evening and asked what their specialty drink was and they said it was a mixture of Earl Grey tea, lemon, kumquat and gin.

I tried it and it was very good. Then I saw they also had some drinks with absinthe and

雖然沒有菜單，但黑板上寫著幾種比較特別的飲料，他們比較喜歡替客人客製化飲料，我點過威士忌酸酒和曼哈頓特調，都很好喝。有一天我比較早到店裡，我就問他們店裡的招牌是什麼，他們說是一種由格雷伯爵茶、檸檬、金桔與琴酒調成的調酒，我覺得很好喝。

我還點過一次苦艾酒調酒，是他們用橘子、萊姆、葡萄柚、卡夏莎還有一些其他的東西調製而成的，也很好喝。雖然調酒有點貴，價格大約在 NT$300 到 NT$350 之間，但他們的調酒品質很好，也需要純熟的技術才能調出那樣的酒來。

The atmosphere is also nice, quiet early in the evening with good music playing. Later in the evening, it gets more crowded as people are leaving bars that close earlier.

在剛入夜的時候，這裡的氣氛很棒，比較安靜又有著好聽的音樂。但夜深了之後人就變得很多，因為其他酒吧已經都關門了。

貓店長的故事 Cat's story

Moet is named after the champagne, and she has a very happy life at the bar. About three years ago, one of the bartenders found her as a stray in Yonghe. She was friendly to him whenever he saw her, so he decided to bring her to work with him, and she's lived at the bar ever since. She loves to be petted and also likes chasing toys around. If you come to the bar alone, she'll be glad to sit beside you. The bar used to allow smoking inside, but now it is non-smoking because secondhand smoke is bad for cats' health.

Moet 的名字來自於一款香檳酒，她在酒吧裡過得相當開心。大概三年前，其中一名酒保發現了雖是流浪貓卻非常親人的她，便將她帶來酒吧工作，而從那之後，Moet 就一直住在酒吧裡了。客人和酒保都很喜歡她，她也享受人們的撫摸。如果你是獨自來到酒吧，她還會陪著你。以前客人可以在酒吧裡面抽菸，但是因為菸對貓的身體不好，所以現在客人想抽菸的話得到外面去抽。

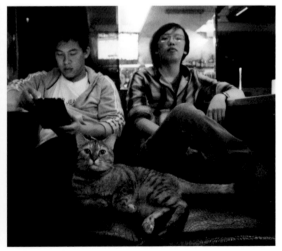

 我的感想 My overall opinion

This is a great bar because the cat is so playful and friendly. The first time I went, I was with a friend at another bar and someone told me there was a bar nearby with a cat, so I just had to check it out. I think it's nice to see how the bartenders take care of the cat— I saw them cutting her nails and giving her treats, and it's also good that they stopped smoking inside because of her. And in addition to the adorable cat, they also probably have the most unique cocktails in Taipei.

這間酒吧很棒，因為貓很可愛也很活潑。我第一次去的那天晚上，我原本是跟朋友在別家酒吧，但有人告訴我附近有家貓酒吧，說我肯定會感興趣。看到酒保呵護貓咪的樣子真的很棒，我看到他們幫她修趾甲、餵她吃零食，甚至還為了她而決定在酒吧裡面禁菸。除了可愛的貓咪以外，我覺得他們的調酒可能也是全臺北最特別的。

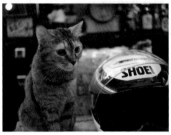

地　　址：從臺北車站到猴硐站大概一個小時
Address ： About an hour by train from Taipei Main Station to
　　　　　 Houtong Station
營業時間 Hours ：推薦 10:00 － 19:00 因為大部分的店都在
這段時間裡營業 Anytime, recommend 10:00 － 19:00 as that's
when most shops are open .

2 猴硐貓村
★★★★☆
Houtong Cat Village

This isn't a cat café; it's a whole village devoted to cats. Once a coal mining town, Houtong is now a tourist attraction, a sanctuary for dozens of stray cats. As soon as the train pulls in, you'll know you've arrived in cat town.

猴硐貓村是一個以貓為主題的村子，猴硐原本是個礦村，但現在卻成了觀光的熱門景點，這個村子裡頭有上百隻的流浪貓。只要火車一停妥，你馬上就會知道自己來到了貓村。

From the station to the village, there's a covered bridge designed as a place where the cats can take

shelter. It has shelves for the cats to climb and jump on, bowls for food and water, and even a couple of litter boxes.

從火車站到村子的路上有一座帶有頂棚的橋，下雨天貓可以在這裡躲雨，有架子供貓咪們爬上爬下，橋上還有食物、飲水和貓砂盆。

There are lots of little shops selling cat-themed products, and most of the shopkeepers have

adopted at least one cat. You can buy cat-shaped pineapple cakes, cupcakes decorated with cats, postcards, mugs and just about any other cat-themed souvenirs you can imagine.

村子裡有許多店家都在賣以貓為主題的東西，大部分的老闆也都有養貓，人們可以在這裡買到鳳梨酥、杯子蛋糕、明信片、馬克杯還有許許多多跟貓有關的紀念商品。

The one cat café I'm listing separately is 217 Café（P.116）because I think that's the best; there are other sort of cat cafés but since there are so many cats wandering in and out of shops and cafés here, it's hard to say that anything isn't a cat café/business. There's even a cat art gallery selling the work of Pepe Shimada, which is also sold in the Taipei café Anhe 65（P.12）North Taiwan Brewery's Neko beer, with

labels designed by the artist, is also popular here.

我另外寫了一篇關於 217 咖啡（P.116）的文章，因為我覺得它是猴硐最棒的貓咖啡廳，當然還有許多店家裡也有貓咪跑來跑去，彷彿整個村子裡面到處都是貓咖啡廳。村裡有家藝廊在賣 Pepe Shimada 的作品，他的作品在臺北的安和 65（P.12）也買得到。另外北臺灣麥酒貓啤酒在這裡也很受歡迎。

 貓店長的故事 Cat's story

Most of the cats have a similar story; they were bred and born here, although TNR efforts have helped to curb the cat population growth. There are a lot of cats here with clipped ears, showing that they've been neutered by TNR.

Because so many cat lovers visit each

day, most of the cats are friendly and let people pet them. Some will even jump into your lap. Unfortunately, some people abandon cats here, though there are signs strongly discouraging this.

這裡大部分的貓都有共同的故事，他們在這裡繁殖與成長，不過最近這裡有實施 TNR，所以貓口有開始受到控制。這裡有很多貓的耳朵都有做剪耳的記號，代表它們都已經被 TNR。

因為有許多愛貓的人常常過來，所以大部分的街貓都很親人，也願意被人撫摸，有些貓還會跳到人的大腿上。但很遺憾的是，也有一些人會帶貓來這裡丟棄，貓村立有很多告示牌告知人們不要這樣做。

我的感想 My overall opinion

At first, I was a little apprehensive about going there because I thought it would be sad to see so many homeless cats. The town does a lot to make sure that they're comfortable, though, and I was happy that it wasn't completely overrun and that the breeding was under control. The little cat houses and all the shops are very cute, and the cats are sweet. I still feel sorry for some of them because I think all cats should have a loving home. There was thin calico kitty that sat in my lap for some time and I wished I could take her home, though I knew my two cats would not appreciate that. But perhaps seeing these cats here will motivate more people to adopt.

起初，我有點擔心到了那裡會看到許多無家可歸的貓，但這些貓的生活看起來還不錯，有人餵牠們、替牠們節育。小貓的屋子跟貓主題的店家都很可愛，貓也是。不過，我還是覺得這些貓應該有個溫暖的家，所以我仍然覺得有點遺憾。有一隻小花斑貓跑來坐在我身上，讓我好想帶她回家，可惜的是我已經養了兩隻貓，牠們不會希望我又多帶貓回家的。希望有更多人能領養這些貓咪。

貓酒吧 Old'98 的貓店長

3 特選 / 更多貓店長
More places with cats

These are a few more shops that have one or more cats.

這些是更多有貓的商店．

地　　址：臺北市大安區羅斯福路三段 21 號
Address ：No.21, Sec. 3, Roosevelt Rd., Da'an Dist., Taipei City
營業時間 Hours ：週一一週六 Monday — Saturday 11:00 — 21:30
週日 Sunday 15:00 — 20:00, 每月第二、第四週日公休
Closed 2nd and 4th Sundays
電　　話 Phone ：02-2363-6093

3.1 明台眼鏡
★★★★★
Ming Tai glasses

I was just walking by this optician's when I noticed a fluffy orange cat in the window. At that time, I just took a picture of him in the window. Later, I went back and found out they have two more cats inside! All three are sweet, lazy Persians, nice to have around while you're shopping for glasses.

　　當我走經這家眼鏡行時，我發現有隻毛茸茸的橘貓在裡頭。那時，我就拍了一張他的照片。稍後，當我走回去的時候，我發現裡頭還有另外兩隻。牠們三隻都是可愛又慵懶的波斯貓，去買眼鏡的人看到牠們應該會很開心。

地　　址：臺北市中正區汀洲路三段 223 號
Address ： No.223, Sec. 3, Tingzhou Rd., Zhongzheng Dist., Taipei City
營業時間 Hours ：週二一週日 Tuesday — Sunday 9:00 — 22:00
週一公休 Closed Mondays
電　話 Phone ： 02-2368-2260

公館舊書城
Gongguan Used Bookstore ★★★★★

I first saw this used bookstore when I lived at Gongguan in 2008 and the same beautiful white cat is still there, usually sitting in his favorite place on the counter. They got a brown tabby kitten a couple of years ago and it's still there sometimes, but it isn't as friendly. It has a picture in the window too, though.

我第一次看到這間舊書店是在二〇〇八年、我還住在公館的時候，當時的小白貓至今還是在店裡，通常坐在櫃檯他最喜歡的那個位置上。幾年前，他們又多了另一隻比較小的虎斑貓，但是牠比較怕生。書店的窗戶上還貼有牠的照片。

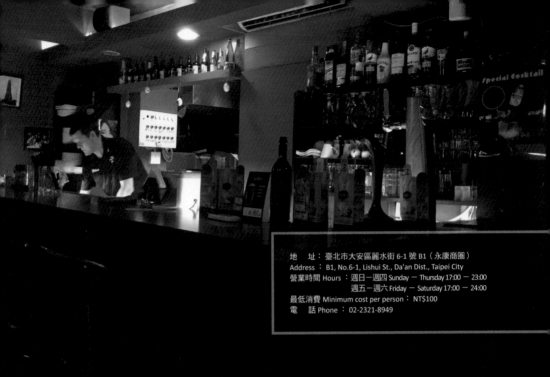

地　　址：臺北市大安區麗水街 6-1 號 B1（永康商圈）
Address ： B1, No.6-1, Lishui St., Da'an Dist., Taipei City
營業時間 Hours ：週日－週四 Sunday － Thursday 17:00 － 23:00
　　　　　　　 週五－週六 Friday － Saturday 17:00 － 24:00
最低消費 Minimum cost per person：NT$100
電　　話 Phone ： 02-2321-8949

巷貓披薩
Alleycat's Pizza ★★★★☆

The Lishui Street Alleycat's is the original of a chain of pizza places around Taipei. It is still home to the original namesake cat, Alley. There are also two cats at the Tianmu branch and at least one at the Huashan branch. I've had the garlic bread（NT$100）, which comes with a very good Caesar dressing dip, and a Napoletana pizza（tomato, goat cheese, olives and spinach NT$470）. The pizza is delicious and there are many varieties to choose from. There are also plenty of drink choices available. Cat themed decorations are all around, some of them cute, others a little creepy.

現在臺北大概有十間巷貓披薩的分店，而麗水這間是他們的創始店，這裡也是跟店同名的貓，Alley 的家。在天母分店有兩隻貓，華山分店也有一隻。我吃過他們的香烤大蒜麵包（NT$100）跟那布勒斯披薩（上面有生鮮番茄、羊奶起司、鯷魚、橄欖和菠菜，NT$470），披薩滿不錯的，有很多口味可以選，還有很多種飲料。店裡有許多跟貓有關的裝飾品，雖然有些很可愛，但有些就讓人覺得有點詭異了。

Chapter5
不只有貓的寵物咖啡館
Pet cafés

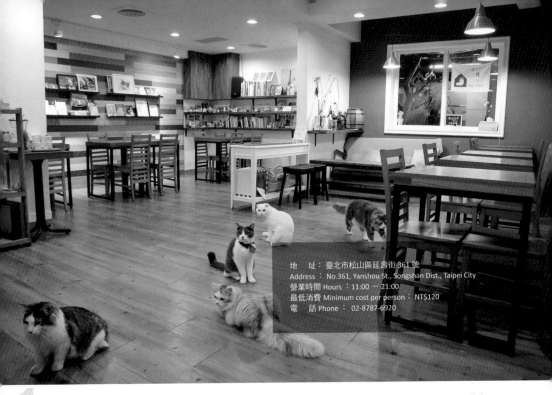

地　　址：臺北市松山區延壽街 361 號
Address：No.361, Yanshou St., Songshan Dist., Taipei City
營業時間 Hours：11:00 － 21:00
最低消費 Minimum cost per person：NT$120
電　　話 Phone：02-8787-6920

小春日和
Spring Day Pet Café
★★★★★

This "pet café " with both cats and dogs is near Café Ballet（P.24） in Minsheng Neighborhood. People can also bring their own pets to the café. The café is very clean, despite the number of dogs, and also has cute pet-related decor. The café has about 6-9 cats （though usually only three or four are out in the café at a time） and there are always at least a couple of dogs belonging to customers or staff. The first time I went, a brown poodle greeted me ecstatically and jumped on my lap. The cats are more stand-offish, but clever and playful.

The customers'dogs are well-behaved, and I haven't seen any 'accidents'. The café also offers dog grooming services.

這家寵物咖啡館有貓也有狗，它位在民生社區裡，離芭蕾咖啡很近（P.24）。客人可以帶寵物來店裡，而店裡保持得非常乾淨，還有許多可愛的裝飾。他們有六到九隻貓，平常在店裡只會看到三、四隻，其他的貓都在後面的房間裡，不過店裡還會有客人與店員帶來的狗。我第一次去的時候，有隻咖啡色的捲毛狗很開心地撲到我身上。雖然貓不像狗那麼熱情，但牠們

還是很聰明、很可愛。

客人的狗都很乖，不會隨地大小便。咖啡廳裡也提供寵物美容的服務。

The menu has the usual coffee, tea and light meal options. The first time I went, I ordered a chocolate banana Frappuccino （NT$160）, which was very good. I've also had a cranberry Frappuccino （NT$160）, refreshing on an unseasonably warm day, and a latte （NT$120）.

菜單上有常見的咖啡、茶和簡餐。第一次到訪時，我喝到非常棒的巧克力香蕉冰沙（NT$160），我也點過蔓越莓冰沙（NT$160），為異常炎熱的時光中帶來一股清涼。還有拿鐵（NT$120）。

貓店長的故事 Cat's story

Although there's a warning that she might bite if you bother her, by far the most impressive cat of this café is Milu. She'll do tricks like a dog for treats! On command, she'll sit, shake hands and catch a treat in her two little paws. She's a mix of American shorthair and Scottish fold and she's adorable to watch.

雖然菜單上有警告，要客人不要打擾咪嚕，因為牠可能會咬人，但咪嚕是店裡最聰明也最特別的貓。牠會跟狗一樣表演特技，牠會坐下、握手，還會用兩隻趾爪抓零食。牠是美國短毛貓和蘇格蘭摺耳貓的混種，很可愛。

It's unusual to find a cat that can do tricks, but a grey and white cat named Sheme (given the name because his wide eyes make it look like he's asking 'What?') can also shake hands. He doesn't do it quite as reliably on command as Milu does, however. They've raised all the cats from very young kittens and started training them then.

會表演特技的貓很少見，但他們還有另一隻叫做「什麼」的灰白貓（因為他的眼睛很大，彷彿是一直在問「什麼？」）也會握手，但他不會像咪嚕每次都聽從指示。牠們都是從小就開始接受訓練的。

 我的感想 My overall opinion

Although of course I prefer cats to dogs, being greeted by the adorable little dog gave me a great first impression. The seats are comfortable and there is plenty of space to relax and play with the pets. I was surprised at how well they all get along and tolerated other people's pets. It's quiet enough to read or work, but also a good place to go with friends, be they animal or human.

　雖然我比較喜歡貓咪，但是看到可愛的狗狗還是讓我對這家店有了很好的印象。椅子很舒服，店裡也有很大的空間讓人放鬆、跟寵物玩，無論是貓或狗都很好相處，牠們也很習慣客人帶來的寵物。環境夠安靜，可以看書、工作，也很適合跟朋友一起去，無論是人還是寵物。

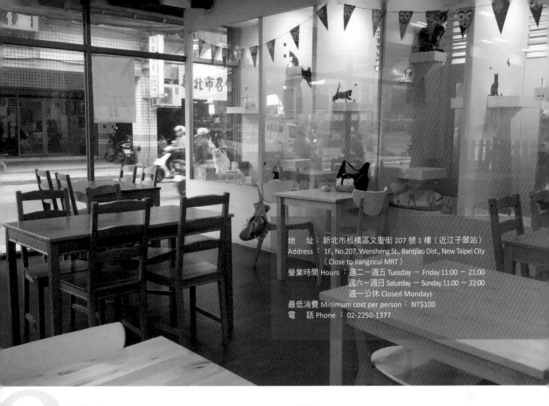

地　　址：新北市板橋區文聖街 207 號 1 樓（近江子翠站）
Address ： 1F., No.207, Wensheng St., Banqiao Dist., New Taipei City
（Close to Jiangzicui MRT）
營業時間 Hours ： 週二—週五 Tuesday — Friday 11:00 — 21:00
週六—週日 Saturday — Sunday 11:00 — 22:00
週一公休 Closed Mondays
最低消費 Minimum cost per person ： NT$100
電　　話 Phone ： 02-2250-1377

2 堤杯
Tiere

★★★★☆

This Banqiao pet café/pet hotel is a bit more dog-focused in that people bring their dogs there and the café's own dogs are out in the dining area while the cats are shut in a separate area. But they do have lots of adorable cats, and the main café dog, Hook, is very sweet.

Customers' dogs are required to wear diapers to prevent 'accidents' and the ones I've seen have been well-behaved.

外」，我所見到的狗狗們都很聽話。

The cats are in an enclosed area and can be seen through the glass. Some

這家位於板橋的寵物咖啡廳／旅館比較像狗咖啡廳，因為客人會帶自己的狗，而老闆養的狗也會在用餐區閒晃，貓則被關在其他房間裡，但店裡確實有許多可愛的貓，狗店長 Hook 也很可愛。

客人的狗都必須穿尿布以免「發生意

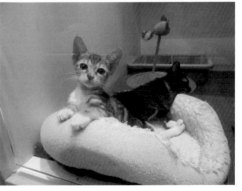

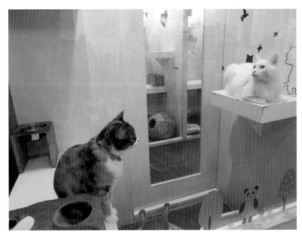

are temporary residents of the pet hotel and others are ones that the café owners have decided to adopt or are putting up for adoption.

貓都被關在貓專屬的區域裡，有些是寵物旅館的住戶，其他要不是老闆已經決定要領養了的，就是開放給客人領養的。

There are lots of cute decorations around, some cat and dog-related and others just interesting, like a collection of Mr Potatoheads.

有很多可愛的裝飾，有些是跟貓或狗有關，另一些還滿有趣的，像是蛋頭先生之類的。

The menu has a good variety of set meals. I've had chicken meatballs and rice that came with black tea（NT$240）. Their coffee is quite good, and they also have beer and soda with cats on the labels.

菜單上有許多套餐可以選擇，我點了雞肉蘑菇番茄飯加紅茶（NT$240）。他們的咖啡也不錯，他們的汽水和啤酒瓶上也都有貓咪的貼紙。

🐱 貓店長的故事 Cat's story

The cats spend most of their time in their own enclosure and are harder to get to know. The real star of this café is Hook, a beautiful Irish setter. Hook was a stray and he was very thin and weak when they found him, so they named him Hook in hopes that he would be tough someday. He did become beautiful and healthy, but his gentle personality is nothing like the legendary villain's. His personality seems more like a cat's. He likes sleeping and being petted, and

he looks elegant when he sits with his paws crossed.

貓大部分的時間都被關在牠們專屬的區域裡，比較難有機會去認識牠們。這家店的明星是 Hook，他是一隻很漂亮的愛爾蘭長毛獵犬。Hook 以前是流浪狗，老闆剛收養他的時候他相當瘦弱，將他命名為 Hook 是希望他將來能強壯一點。Hook 也真的變得很健康、很漂亮，但溫和的性情一點也不像那個傳說中的反派角色，反倒比較像一隻貓，他喜歡睡覺、被摸，趴下時兩隻前腳交叉的樣子非常優雅。

 我的感想 My overall opinion

This is a nice café and the pet hotel looks good, lots of space for the dogs and very clean. It's obvious that the owners care a lot about the animals and are happy to share stories about how they found them. It's a pleasant place to go alone, with friends or with pets（dogs and cats are both welcome）!

　　這家咖啡廳很棒，寵物旅館看起來也很乾淨，有很大的空間讓狗狗活動。老闆很關心寵物，也很樂於跟人們分享他們的故事。無論是要自己去、跟朋友去、帶寵物（貓和狗都歡迎）去都很合適。

小春日和 Spring Day Pet Café 的貓店長

3

特選 / 更多狗狗貓貓
More pet cafés

Here are a few more pet cafes to check out.

這裡有更多不容錯過的狗狗貓貓咖啡館 .

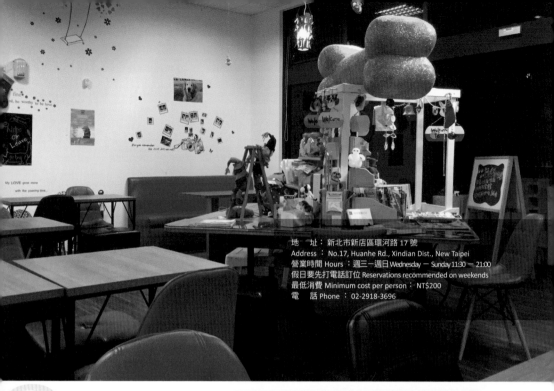

地　　址：新北市新店區環河路 17 號
Address ： No.17, Huanhe Rd., Xindian Dist., New Taipei
營業時間 Hours ：週三一週日 Wednesday — Sunday 11:30 — 21:00
假日要先打電話訂位 Reservations recommended on weekends
最低消費 Minimum cost per person ： NT$200
電　　話 Phone ： 02-2918-3696

狗吧
Go Bar ★★★★☆

This café has four dogs of its own, and customers can also bring their own dogs（or cats if they want to）. The café has a nice atmosphere, especially on a warm afternoon with a fresh breeze blowing through it.

The dogs were very sweet and friendly. My favorite was Meimei, the golden retriever. The other people's dogs were cute, too, though not quite so well behaved.

The café does a very good job of keeping things clean and there are signs asking people to clean up after their pets （and plastic bags provided）.

On the menu, they have a

variety of fried foods, pastas and desserts, as well as the typical coffee drinks. I had a latte （NT$110） and a brownie with ice cream （NT$120）. The coffee really wasn't very

good; I wouldn't order it again. They did have a good selection of beers though.I had Asahi beer (NT$100) and that went very well with the onion rings (NT$130).

這家咖啡館有四隻狗,客人也可以帶自己的寵物來。咖啡館的氣氛很好,特別是在溫暖的午後、清新的微風吹拂下更棒。

他們的狗都很可愛,我最喜歡的是妹妹,她是一隻黃金獵犬。客人的狗也很可愛,但就不見得很乖。

我經常看到店員在打掃,所以整體環境還算乾淨。店裡的牌子公告說客人得要清理自己狗狗的大小便,店裡會提供垃圾袋。

菜單上有油炸類食品、義大利麵、點心、咖啡、茶飲等,我點了一杯拿鐵(NT$110)和一個冰淇淋布朗尼(NT$120),但我覺得拿鐵普普通通。他們還有很多種啤酒,看起來還滿不錯的。我比較推薦日式啤酒 (NT$100) 和洋蔥圈很搭 (NT$130)。

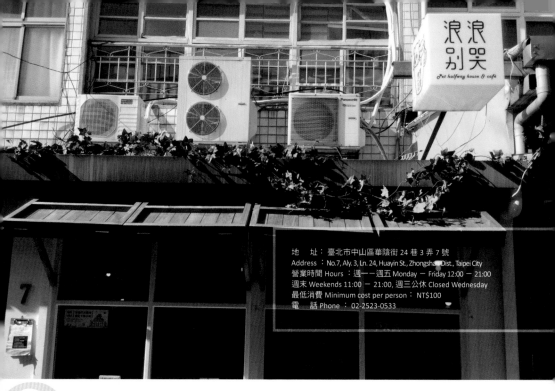

地　　址：臺北市中山區華陰街 24 巷 3 弄 7 號
Address ： No.7, Aly. 3, Ln. 24, Huayin St., Zhongshan Dist., Taipei City
營業時間 Hours ：週一－週五 Monday － Friday 12:00 － 21:00
週末 Weekends 11:00 － 21:00, 週三公休 Closed Wednesday
最低消費 Minimum cost per person： NT$100
電　　話 Phone ： 02-2523-0533

浪浪別哭
Lang Lang Don't Cry ★★★★★

This new café is located in a traditional old house near Taipei Main Station. The owners' grandmother left them the house and she had always helped stray animals, so they wanted to continue her work. They temporarily take in stray dogs and cats, and customers can adopt them. The only permanent resident is the dog 'waiter'. With the café's popularity, it seems that pets are being adopted quickly, which is great. The café is very busy and reservations are recommended. The menu is very cute and includes the story of how the café started.

There's also a page where you can order dog food. 3% of all profit from the café goes to help stray animals.

I had a 'burrito', really more of a wrap

sandwich, that came with salad, fries and black tea （NT$240）. It was pretty good. The menu is simple, with only a few meal and drink options. This is a nice place to visit and a good way to help stray animals.

　　這家新開的寵物咖啡廳在臺北車站附近、一間老式傳統建築裡。老闆的奶奶以前住在這裡，她經常照顧流浪動物。奶奶去世之後，老闆便開了這間寵物咖啡廳，繼續幫助流浪動物。他們的餐廳裡會有一些流浪動物，客人可以領養牠們，只有一隻狗狗服務生是一直待在這裡的。這家店最近很熱門，所以許多動物都很快地找到

了新家，這是一件好事。來咖啡廳的客人很多，所以先訂位會比較好。菜單設計得很可愛，裡面有他們的故事，你甚至還可以點狗食。咖啡廳會將 3% 的盈餘拿去幫助流浪動物。

　　我點了墨西哥捲（雖然它看起來比較像三明治）、薯條、沙拉加紅茶，這樣 NT$240。菜單很簡單，沒有多少種選擇。這裡的環境不錯，來這裡消費還能幫助流浪動物。

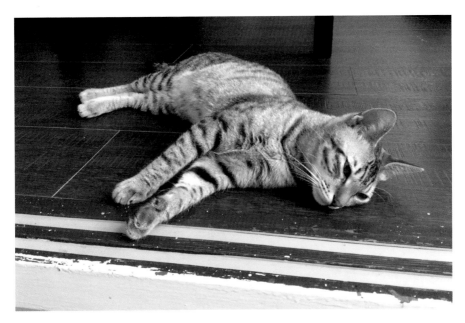

地　　址：臺北市大安區永康街 41 巷 26 號一樓
Address： No.36, Anxi St., Datong Dist., Taipei City
營業時間 Hours：13:00 — 19:00, 週二公休 Closed Tuesdays
最低消費 Minimum cost per person： NT$90
電　　話 Phone： 02-2557-3169

兜味
Doorway Café ★★★★☆

Located near Dihua Shopping Street, this pet café only occasionally has a cat. Still, they have lots of pictures of cats around. People are welcome to bring their own pets, cats or dogs.

The menu has interesting, punny names for the items. I had a yogurt soda with kumquat （NT$100） and French bread with cheese on it （NT$80）. These were very good. The owner also gave me some freshly made little egg cake things.

This is a cute, cozy café and a nice place to work or read even if it doesn't have a cat most of the time.

　　這家咖啡廳離迪化街很近，但
老闆偶爾才會把他的貓帶來。店
裡有許多貓的圖片。客人可以帶
自己的狗或貓到店裡來。

　　菜單很有趣，飲料、食物的名字都好有
創意，我點了「多多很生氣」（NT$100）
跟「孤獨法國佬」（NT$80），味道都滿
不錯的，老闆還特別送了我一些現做的雞
蛋糕。

　　這家咖啡廳很舒服，是個看書、工作的
好地方。雖然老闆的貓平常不會出現，但
還是可以看到其他客人可愛的寵物。

特別致謝
Acknowledgements

Thanks to Café Ballet, Top Point, 217 Café, Robot Station, Fat Cat's Story, Minou Minou, Cat's Tail Café,
Spring Day Café, Sunbeam Cat, Dela1010, Purr Café, Café 218, Old'98 for providing additional photos.
感謝芭蕾咖啡館、突點義大利美食咖啡館、217咖啡、鐵皮駅、肥貓故事館、迷路迷路、貓尾巴咖啡、
小春日和、日光貓、Dela100、咕嚕咕嚕貓咖啡、小猴子咖啡、Old'98 提供的照片。
Thanks to Rebecca Day for finding Fat Cat Deli and writing a guest post on my blog about it,
on which that entry is based.
感謝 Rebecca Day 找到 Fat Cat Deli，並推薦在我的部落格，讓我能在書中介紹。
Thanks also to Ariel Chen for letting me know about several cafes and accompanying me to them.
也感謝 Ariel Chen 推薦給我幾間貓咖啡店，並陪我一起去拜訪。

這裡有貓,歡迎光臨:老外帶路,探訪62間貓店長私藏地圖! / Susan著.
-- 初版. -- 臺中市:晨星, 2016.09　　面;　公分. -- (寵物館;44)
ISBN 978-986-443-173-1(平裝)
1.咖啡館 2.貓 3.臺灣

991.7　　　　　　　　　　　　　　　　　　105014836

寵物館 44

這裡有貓，歡迎光臨
老外帶路，探訪 62 間貓店長私藏地圖！

作者	Ｓｕｓａｎ
主編	李俊翰
美術編輯	蔡艾倫
封面設計	曾德瀚
創辦人	陳銘民
發行所	晨星出版有限公司 臺中市工業區30路1號 TEL：（04）23595820　FAX：（04）23597123 E-mail:service@morningstar.com.tw http://www.morningstar.com.tw 行政院新聞局版台業字第2500號
法律顧問	陳思成律師
初版	西元 2016 年 9 月 1 日
郵政劃撥	22326758（晨星出版有限公司）
讀者服務專線	04-23595819#230
印刷	啟呈印刷股份有限公司

定價 290 元

ISBN 978-986-443-173-1

Printed in Taiwan

以下資料或許太過繁瑣，但卻是我們了解您的唯一途徑
誠摯期待能與您在下一本書中相逢，讓我們一起從閱讀中尋找樂趣吧！

姓名：＿＿＿＿＿＿＿＿＿＿　性別：□ 男　□ 女　生日：　／　／

教育程度：＿＿＿＿＿＿＿＿

職業：□ 學生　　　□ 教師　　　□ 內勤職員　□ 家庭主婦
　　　□ SOHO 族　□ 企業主管　□ 服務業　　□ 製造業
　　　□ 醫藥護理　□ 軍警　　　□ 資訊業　　□ 銷售業務
　　　□ 其他 ＿＿＿＿＿＿＿＿＿＿

E-mail：＿＿＿＿＿＿＿＿＿＿＿＿＿　聯絡電話：＿＿＿＿＿＿＿＿＿＿

聯絡地址：□□□ ＿＿＿＿＿＿＿＿＿＿＿＿＿＿＿＿＿＿＿＿＿＿

購買書名：這裡有貓，歡迎光臨＿＿＿＿＿＿＿＿＿＿＿＿＿＿＿＿

·**本書中最吸引您的是哪一篇文章或哪一段話呢？** ＿＿＿＿＿＿＿＿＿＿＿

·**誘使您購買此書的原因？**

□ 於 ＿＿＿＿ 書店尋找新知時　□ 看 ＿＿＿＿ 報時瞄到　□ 受海報或文案吸引
□ 翻閱 ＿＿＿＿ 雜誌時　□ 親朋好友拍胸脯保證　□ ＿＿＿＿ 電台 DJ 熱情推薦
□ 其他編輯萬萬想不到的過程：＿＿＿＿＿＿＿＿＿＿＿＿＿＿＿＿＿

·**對於本書的評分？**（請填代號：1. 很滿意 2. OK 啦！ 3. 尚可 4. 需改進）

封面設計 ＿＿＿＿＿　版面編排 ＿＿＿＿＿　內容 ＿＿＿＿＿　文／譯筆 ＿＿＿＿＿

·**美好的事物、聲音或影像都很吸引人，但究竟是怎樣的書最能吸引您呢？**

□ 價格殺紅眼的書　□ 內容符合需求　□ 贈品大碗又滿意　□ 我誓死效忠此作者
□ 晨星出版，必屬佳作！　□ 千里相逢，即是有緣　□ 其他原因，請務必告訴我們！

＿＿＿＿＿＿＿＿＿＿＿＿＿＿＿＿＿＿＿＿＿＿＿＿＿＿＿＿＿＿＿

·**您與眾不同的閱讀品味，也請務必與我們分享：**

□ 哲學　　　□ 心理學　　□ 宗教　　　□ 自然生態　□ 流行趨勢　□ 醫療保健
□ 財經企管　□ 史地　　　□ 傳記　　　□ 文學　　　□ 散文　　　□ 原住民
□ 小說　　　□ 親子叢書　□ 休閒旅遊　□ 其他 ＿＿＿＿＿＿＿＿＿＿＿

以上問題想必耗去您不少心力，為免這份心血白費

請務必將此回函郵寄回本社，或傳真至（04）2355-0581，感謝！

若行有餘力，也請不吝賜教，好讓我們可以出版更多更好的書！

·**其他意見：**